PLACE

GEOFFREY JAMES | RUDY WIEBE

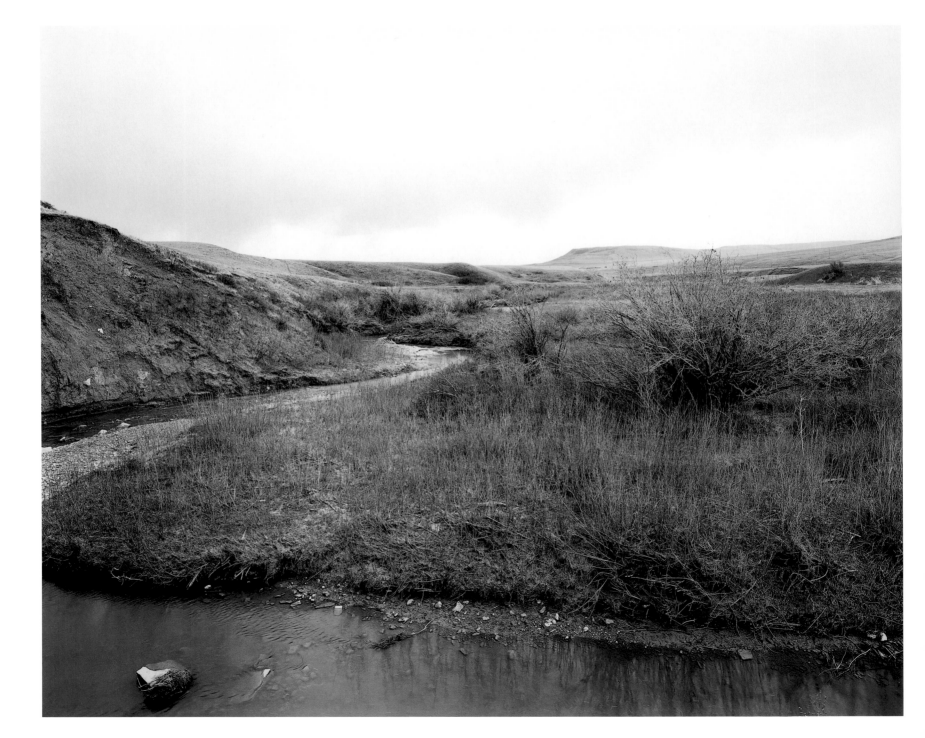

LETHBRIDGE, A CITY ON THE PRAIRIE

Douglas & McIntyre

VANCOUVER/TORONTO

David R. Godine,

Publisher

BOSTON

Southern Alberta
Art Gallery

LETHBRIDGE

Douglas & McIntyre
2323 Quebec Street, Suite 201
Vancouver, British Columbia V5T 4S7

National Library of Canada Cataloguing in Publication Data
James, Geoffrey, 1942–
 Place: Lethbridge, a city on the prairie
 Co-produced by: Southern Alberta Art Gallery.

 ISBN 1-55054-931-6

 1. Lethbridge (Alta.)—History. 2. Lethbridge (Alta.)—
Pictorial works. I. Wiebe, Rudy, 1934– II. Southern Alberta Art
Gallery. III. Title.
FC3699.J35W53 2002 971.23'4503 C2001-911693-4
F1079.5.J35W53 2002

Originated by Douglas & McIntyre and published in
the United States of America by
David R. Godine, Publisher
Post Office Box 450, Jaffrey, New Hampshire 03452
www.godine.com

Library of Congress Control Number 2002109388

Editing by Saeko Usukawa
Jacket design and interior typography by Peter Cocking
Printed and bound in Italy on acid-free paper

Images scanning, printing and binding:
Edizioni Polistampa, Firenze, Italy
info@polistampa.com

The Southern Alberta Art Gallery is indebted to The Canada
Council for the Arts, whose Millennium Fund enabled the
commission of Geoffrey James's Lethbridge photographs
and the text by Rudy Wiebe. We are grateful to the City of
Lethbridge, the Alberta Foundation for the Arts, Phyllis Lambert,
the Ydessa Hendeles Art Foundation and the Gershon Iskowitz
Foundation for additional support.

Douglas & McIntyre gratefully acknowledges the financial
support of the Canada Council for the Arts, the British Columbia
Ministry of Tourism, Small Business and Culture, and the
Government of Canada through the Book Publishing Industry
Development Program (BPIDP) for our publishing activities.

CONTENTS

PREFACE

The photographs in this book had their genesis
thirty years ago, when I visited Lethbridge with
Arthur Erickson to look at his new university build-
ing. It was, and is, an immense structure, as large
as a cruise ship, but riding discreetly below the line
of the prairie. The building was impressive; its sit-
ing even more so. But it was the surrounding
landscape that stayed with me. The coulees that
rise up from the Oldman River, with their flowing,
anthropomorphic forms, assumed in my mind an
almost mythic stature, like the background of a
Leonardo painting. What was astonishing about
them was that, primeval as they seem, they were
right on the edge of town.

 In 1998, when I told Joan Stebbins, then director
of the Southern Alberta Art Gallery, of my interest
in Lethbridge, she kindly invited me to come and

work there, and to exhibit the results. Something that started out as a rather modest effort—perhaps a single extended trip—turned into a millennial project funded by the Canada Council. I worked over the period of a year, with four visits to the city, and had the luxury of time to reflect on what I was doing. In a sense, most of the photographic projects I embark upon are the same, in that, at their conclusion, I have accumulated almost enough knowledge to begin.

This book makes no claim to be a portrait of Lethbridge in any conventional sense. It has neither Erickson's university nor the Japanese garden nor the few good examples of contemporary architecture in the city. Instead, I have worked with subjects that move me: with a certain kind of modest vernacular architecture, with remnants of history, with structures that bear the marks of a past that, as Rudy Wiebe's eloquent stories indicate, have been largely effaced. At another level, the photographs deal with how the people of Lethbridge live with the overwhelmingly beautiful landscape that surrounds them. This relationship is not always easy. The coulees that Erickson was so careful to respect are now being swarmed by tract housing. This phenomenon is not particular to Lethbridge—it is visible on the edge of every North American city. But here, the invasion seems particularly poignant. Too often, the human habitations seem indifferent to what surrounds them. In their turn, the landforms retain a strength that makes the human presence appear, at times, almost provisional.

GEOFFREY JAMES

12

APPROACHES

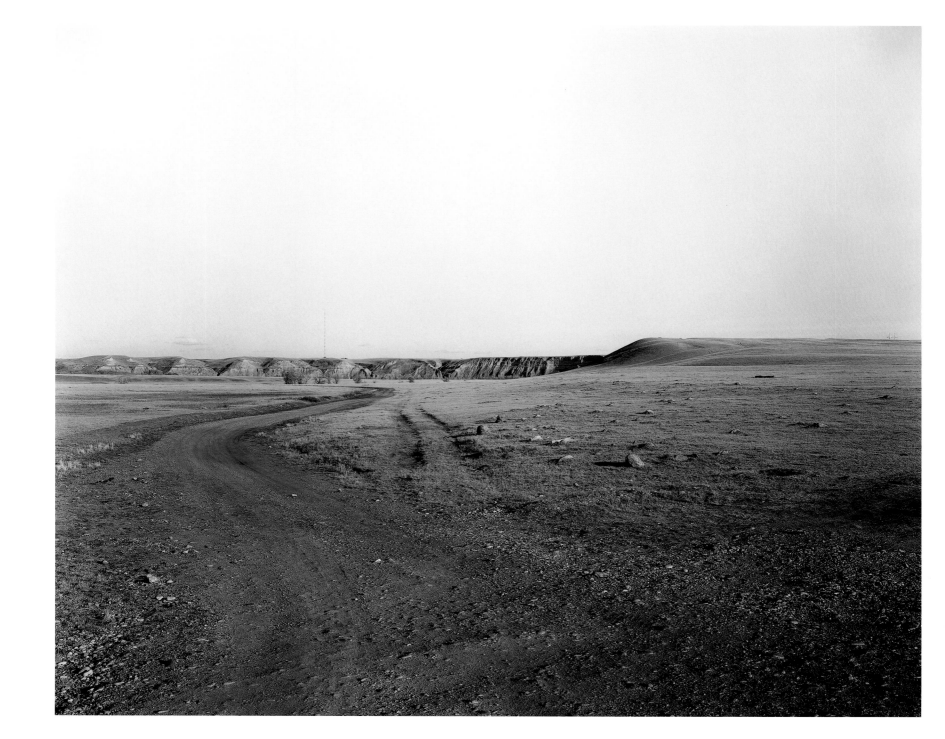

16

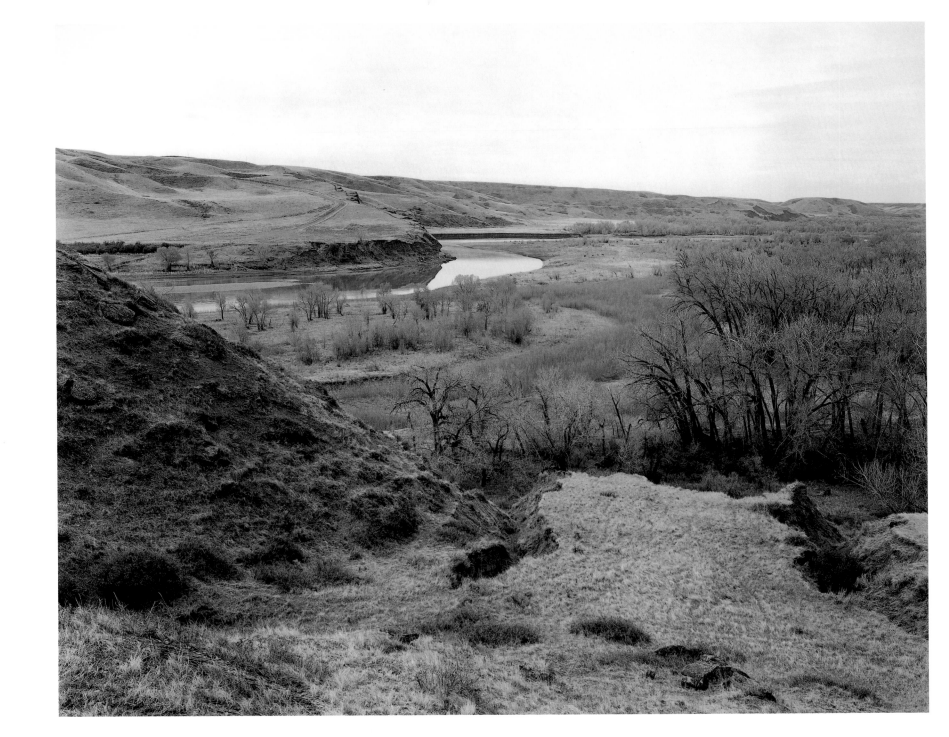

18

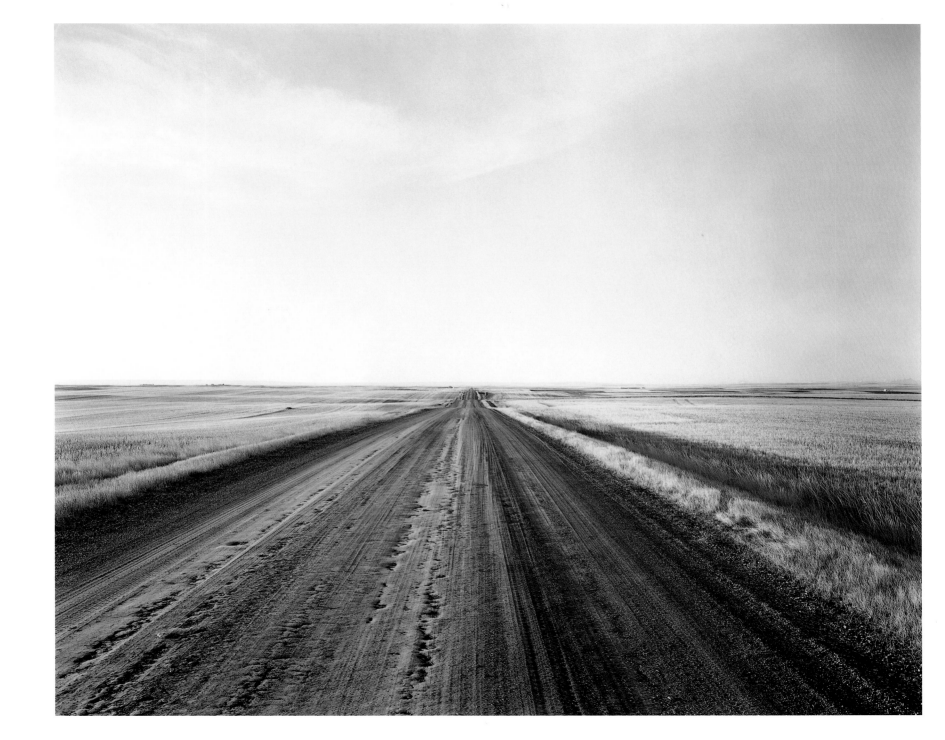

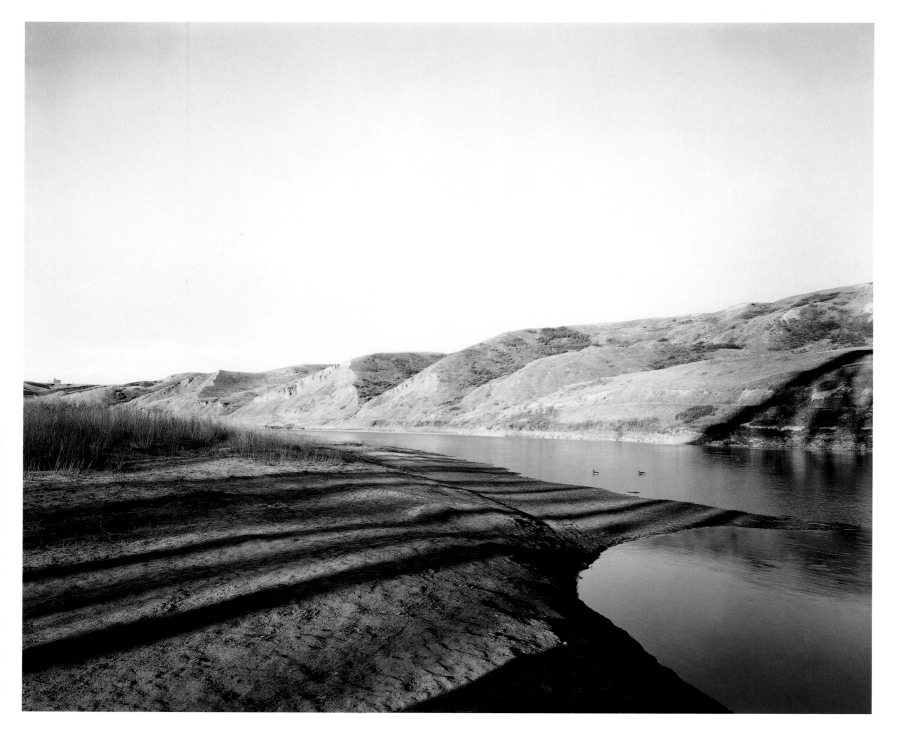

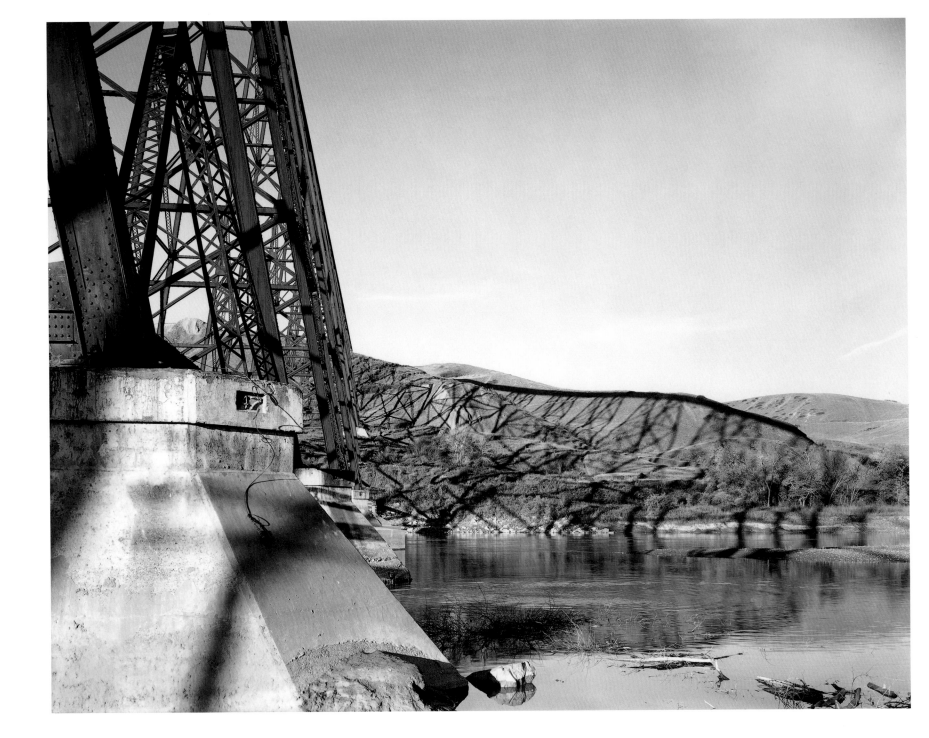

IN THE CITY

24

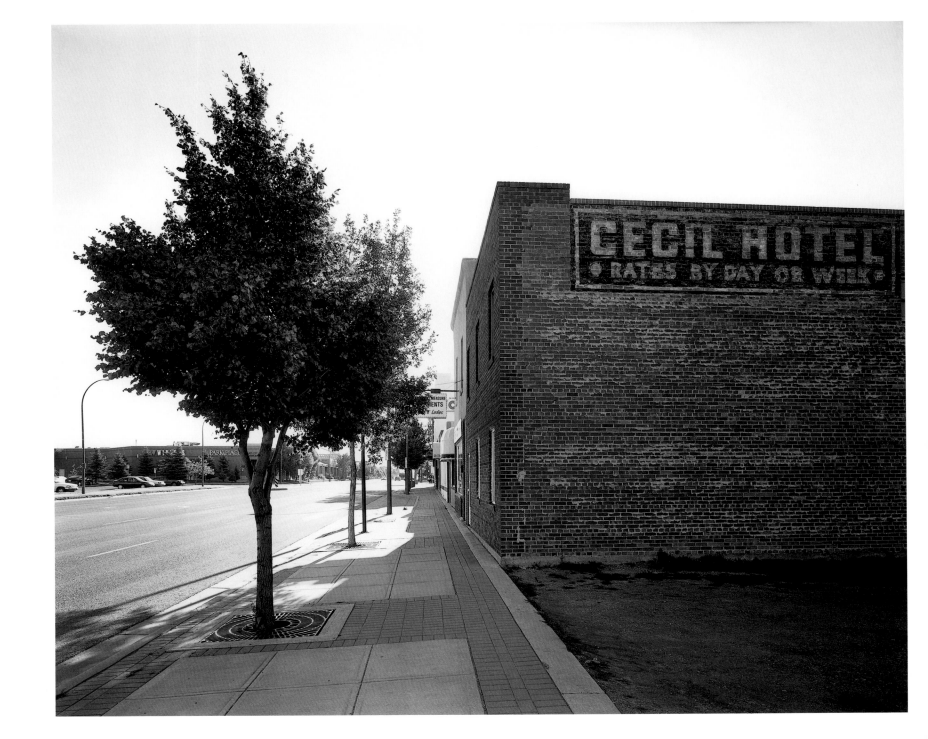

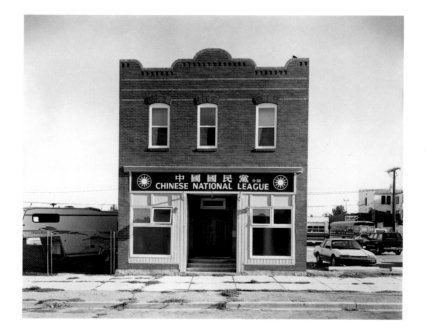

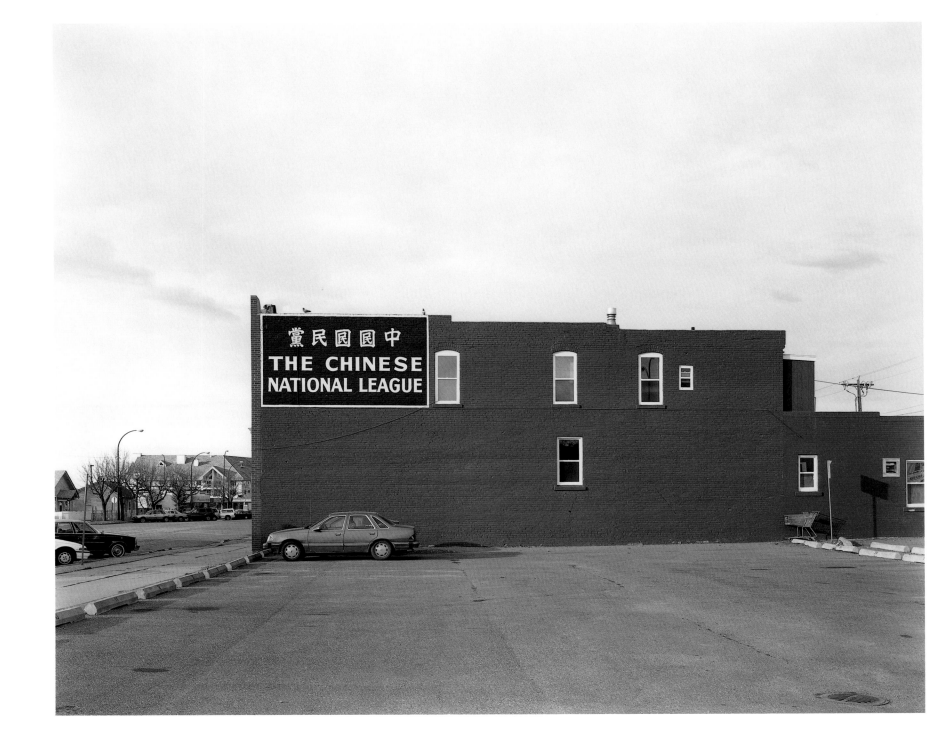

28

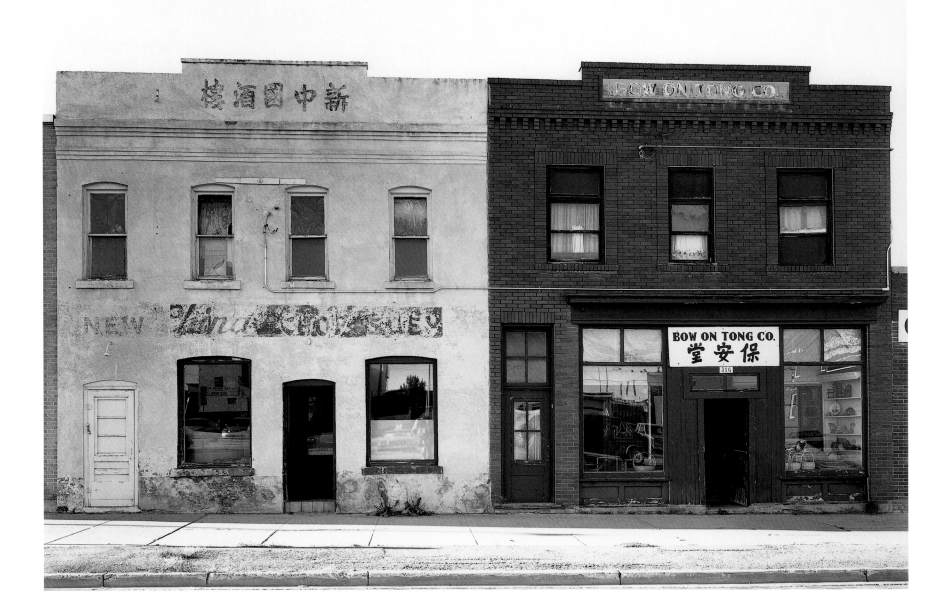

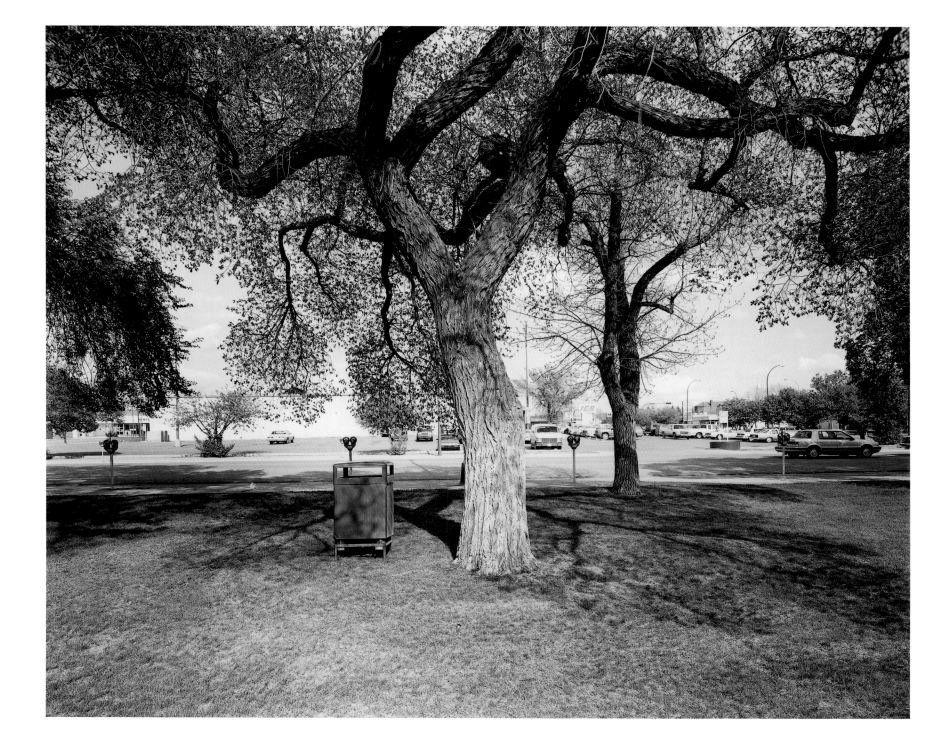

32

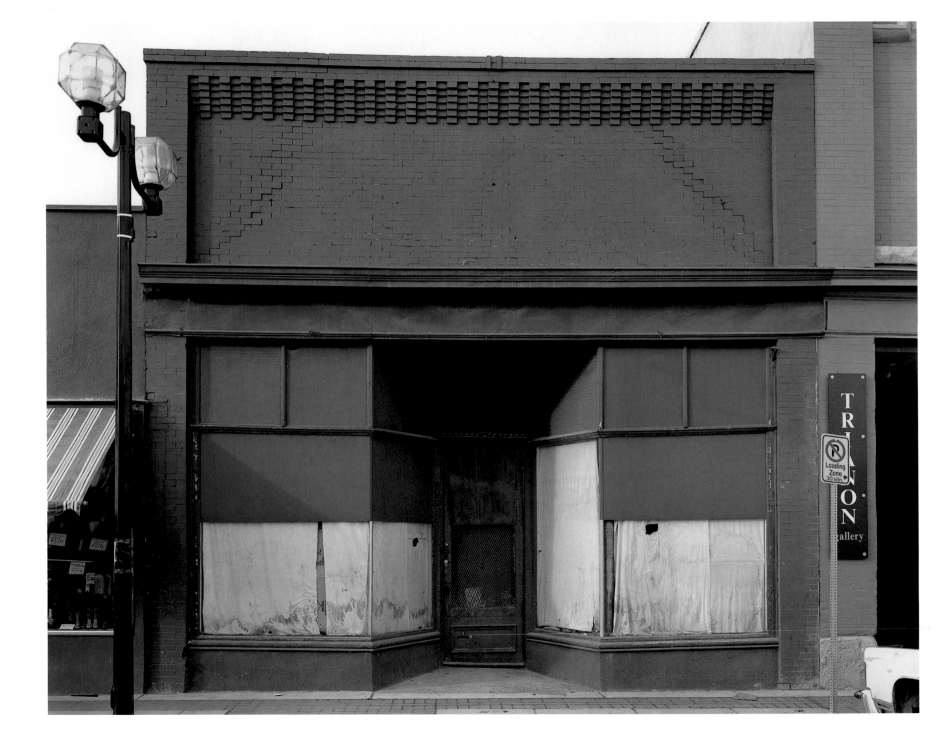

34

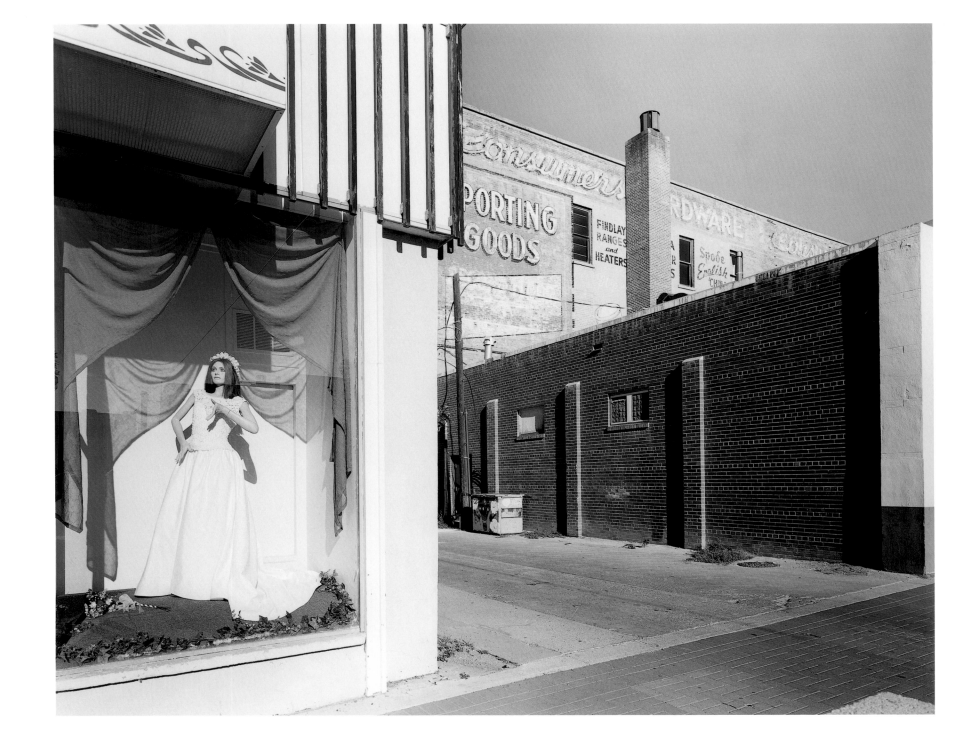

36

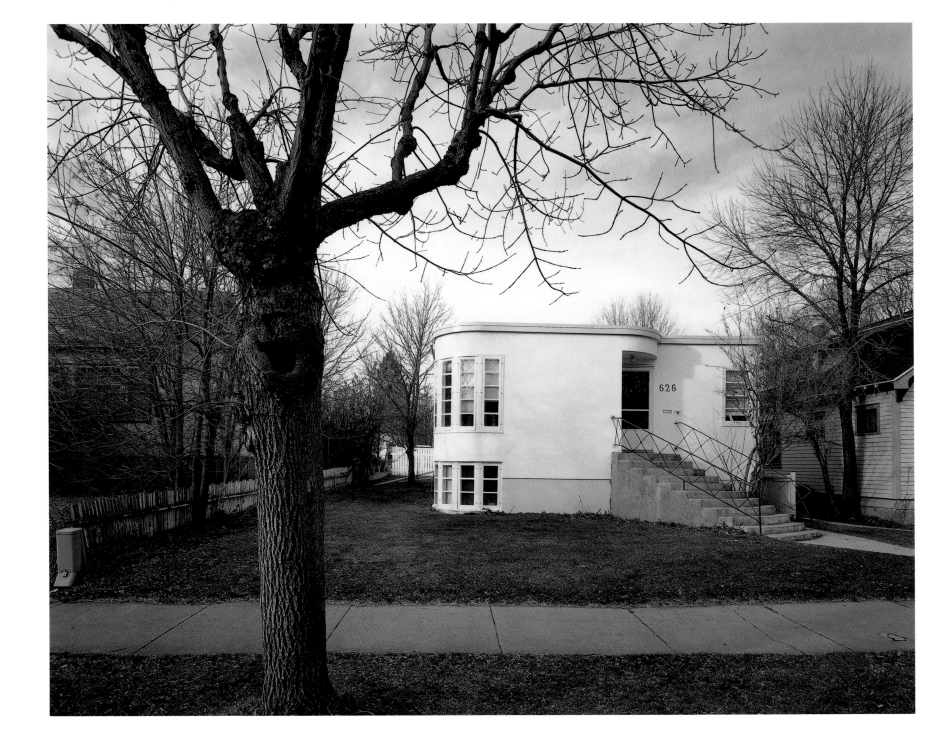

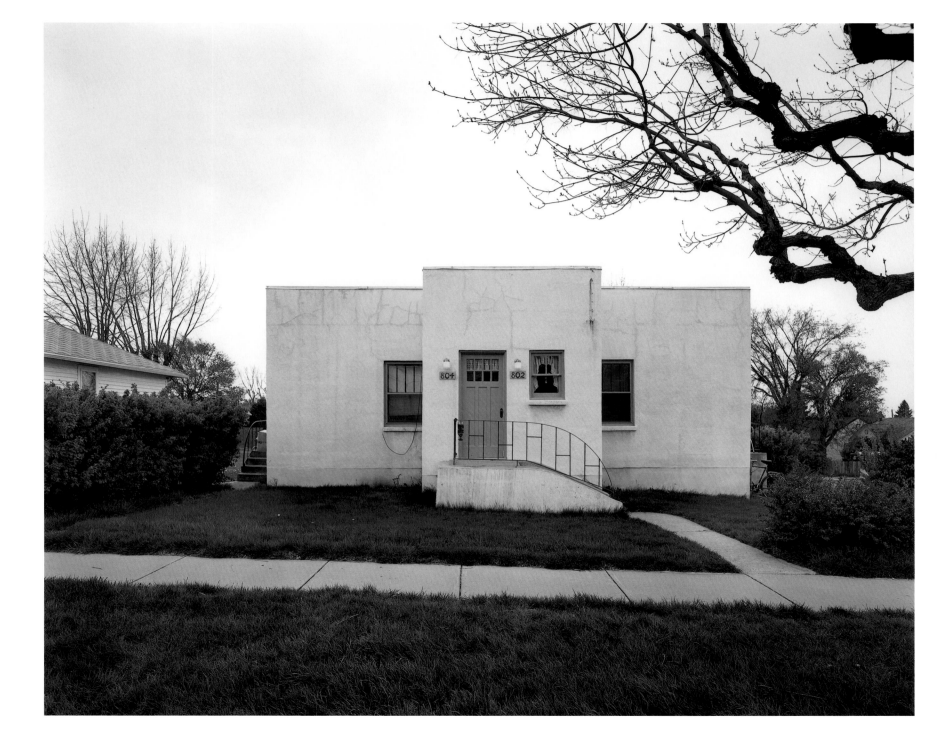

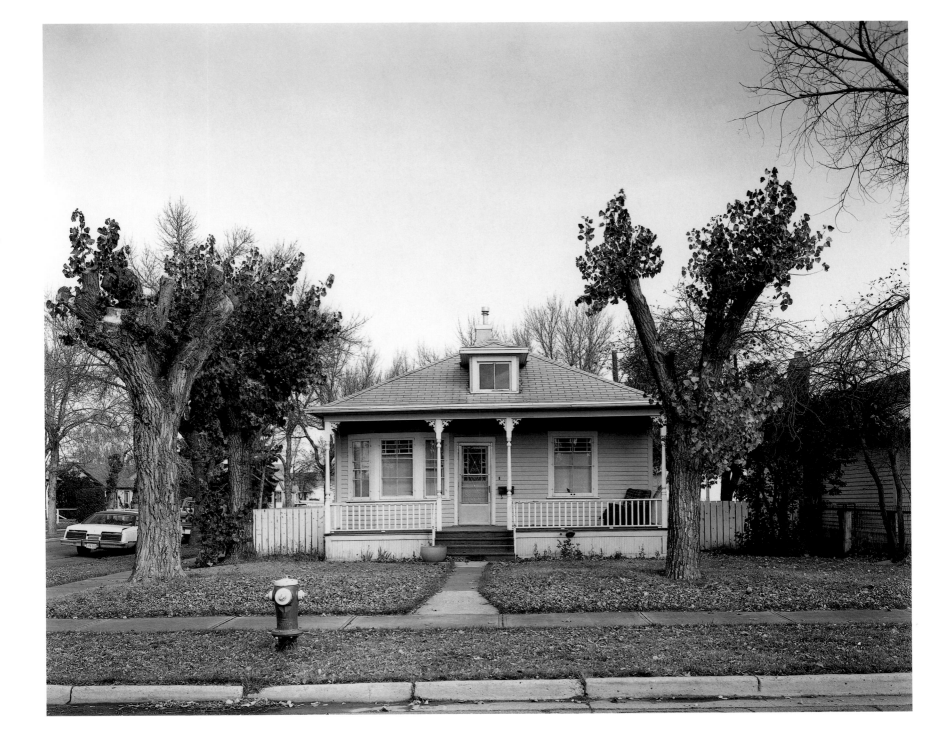

42

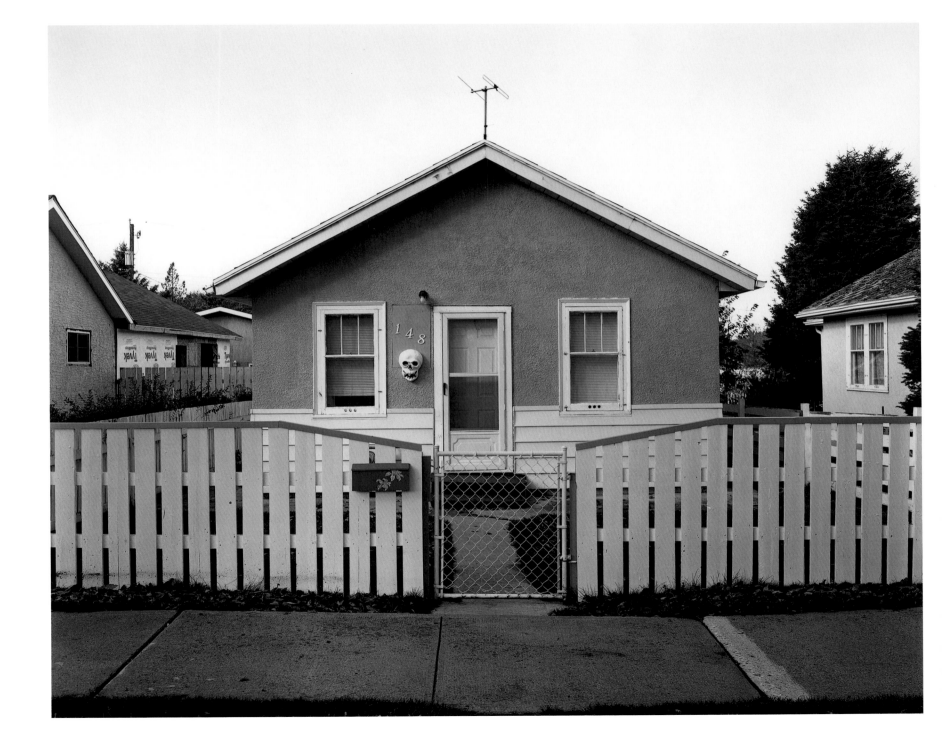

44

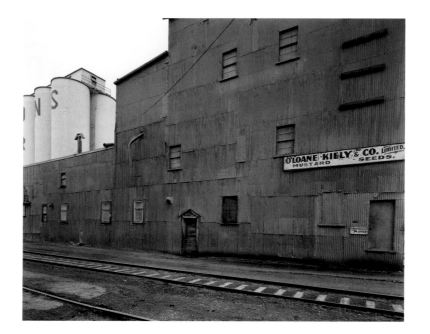

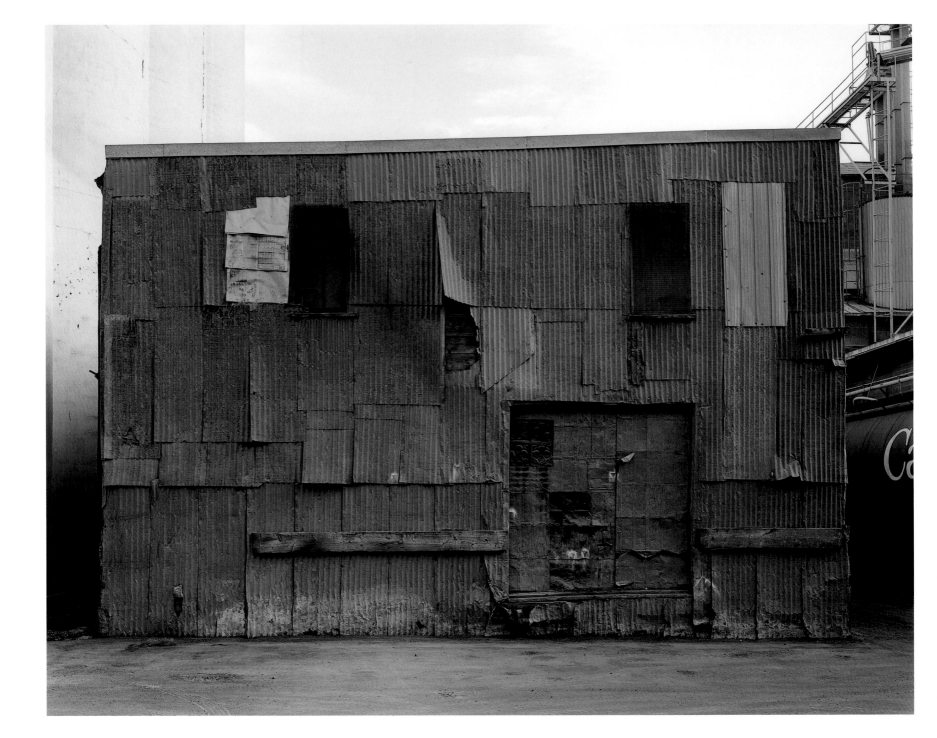

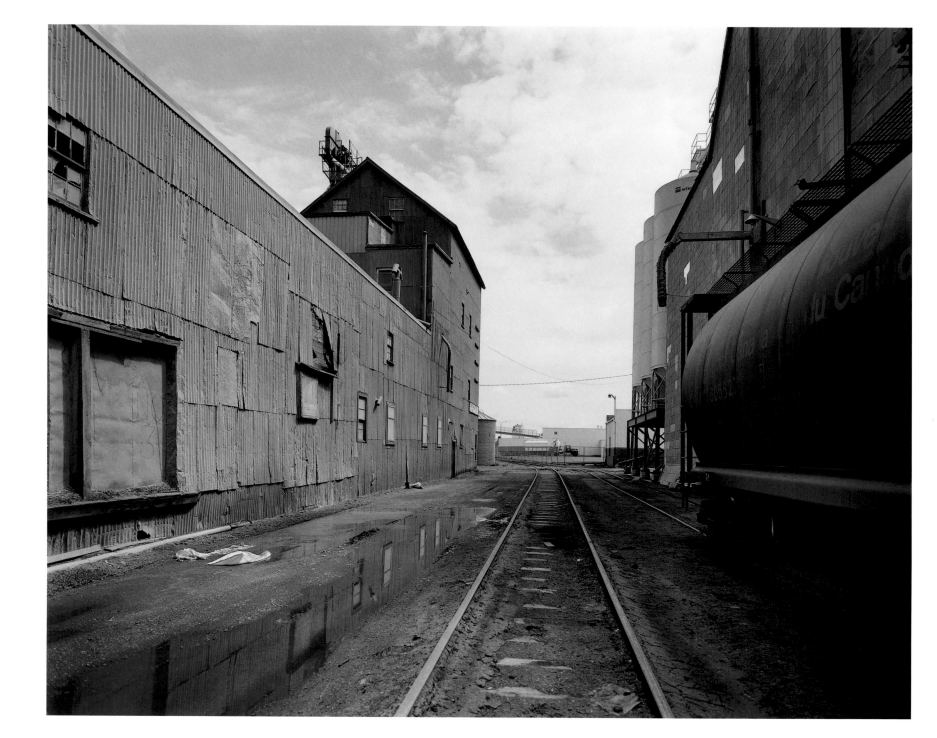

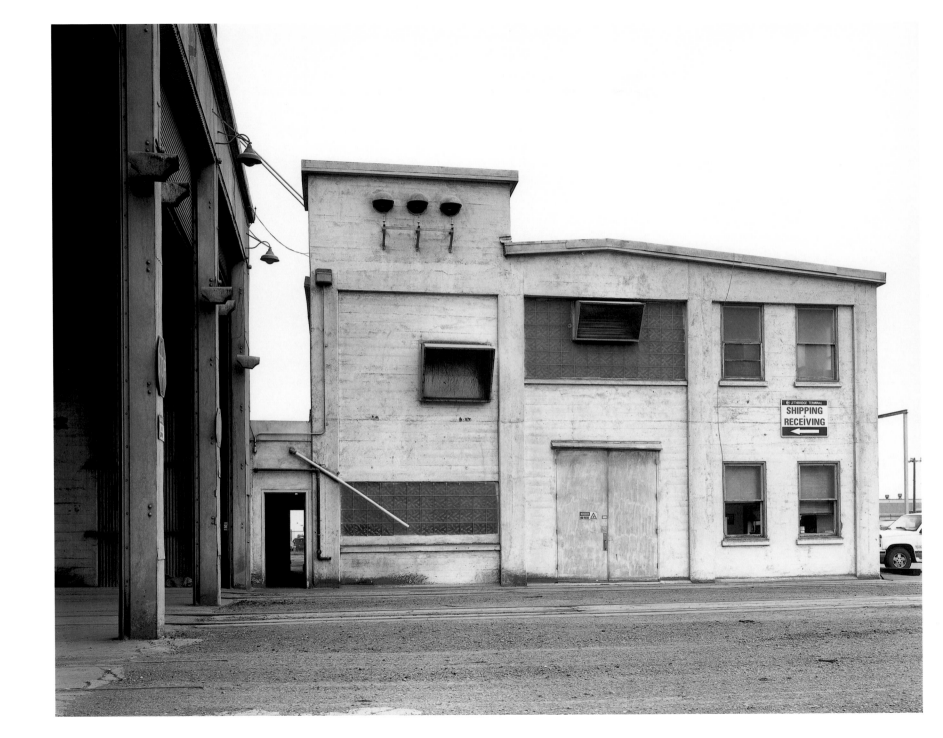

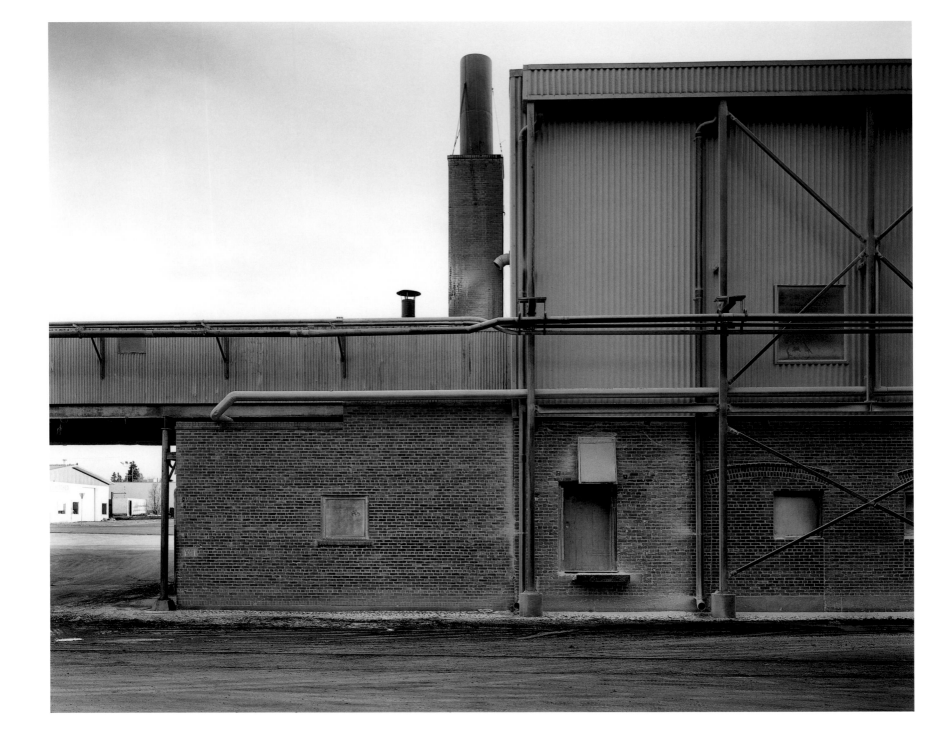

52

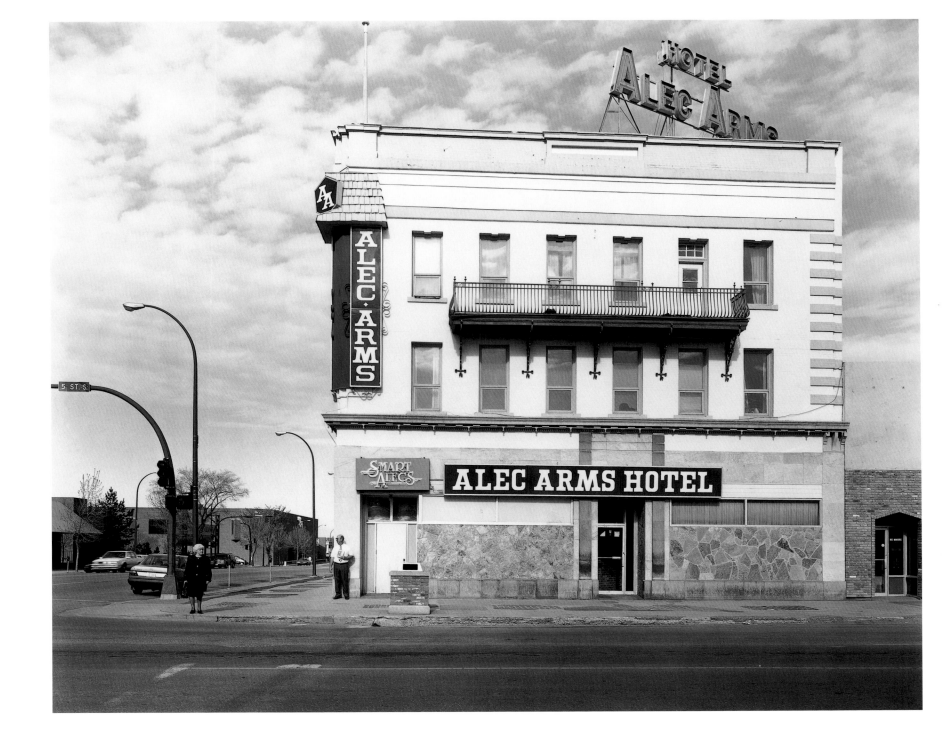

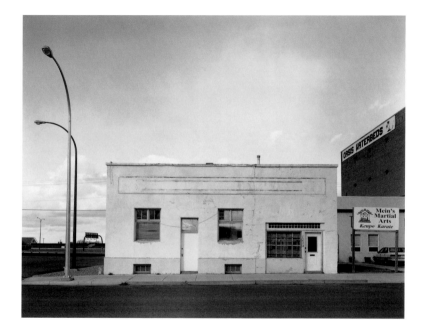

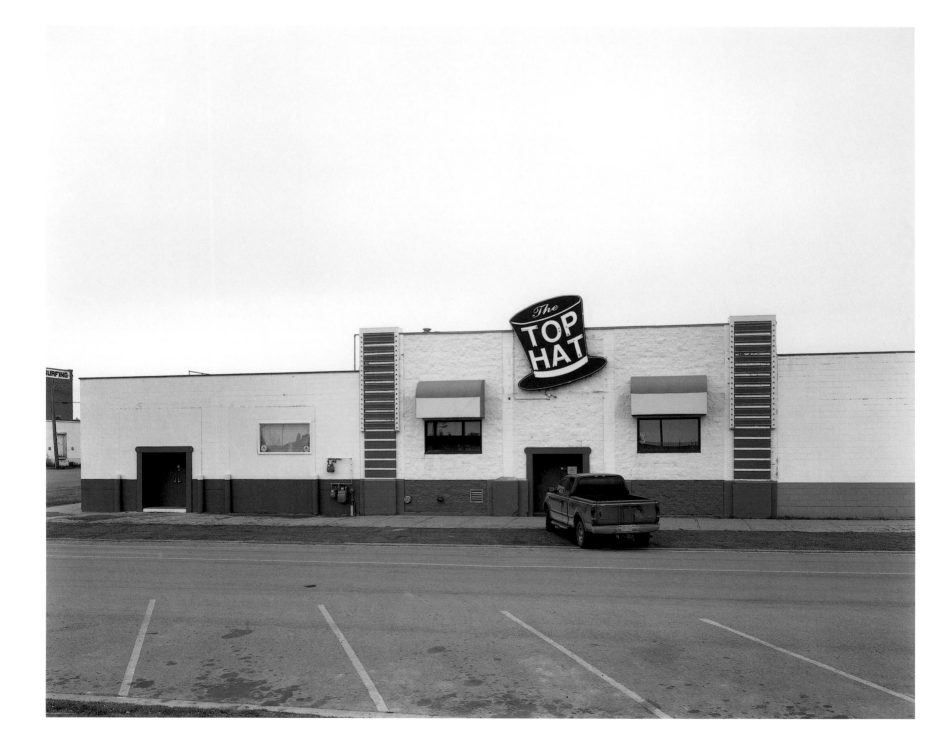

56

A BETTER WAY OF LIFE

58

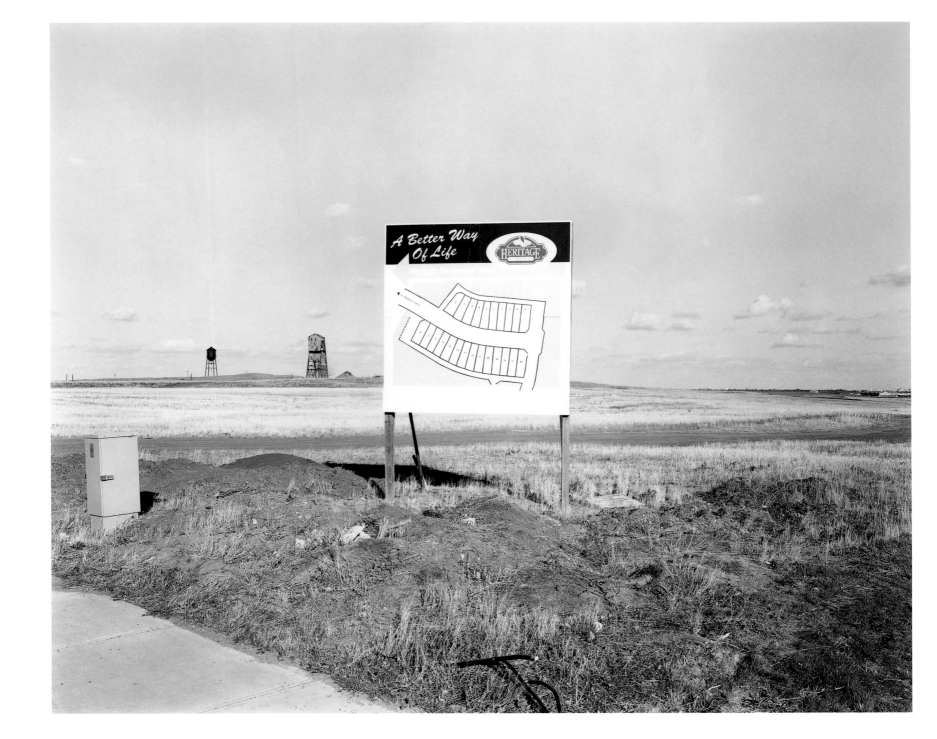

60

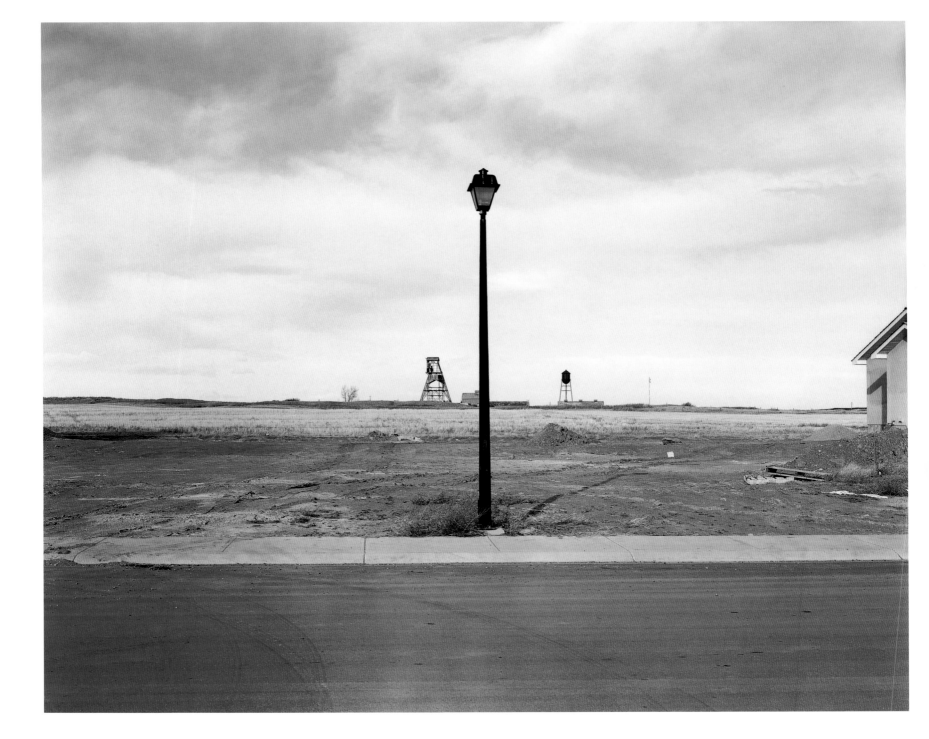

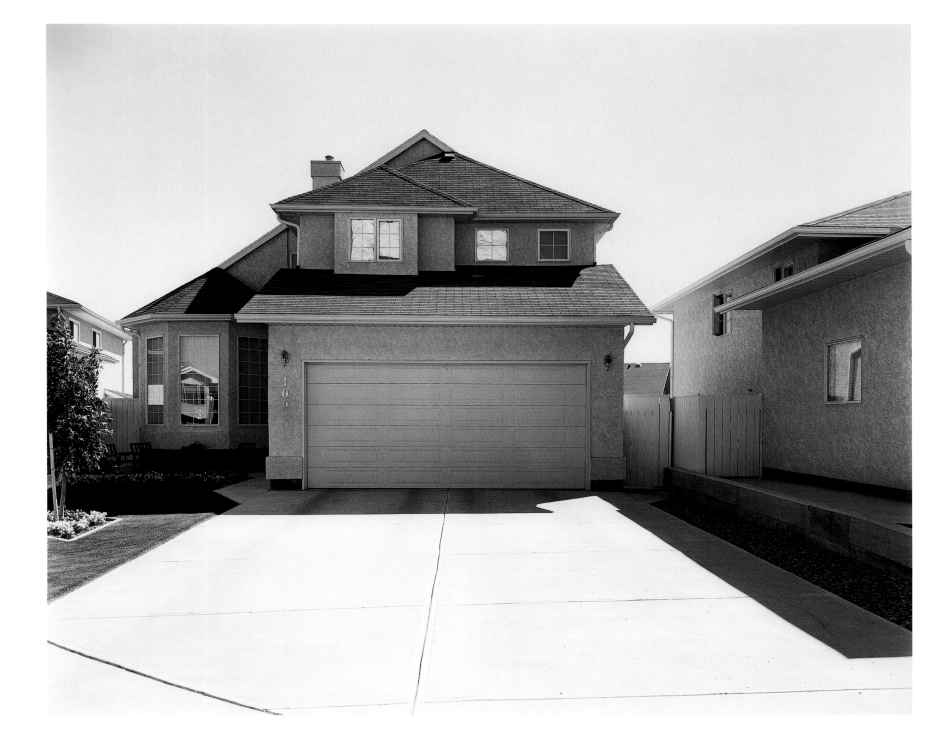

64

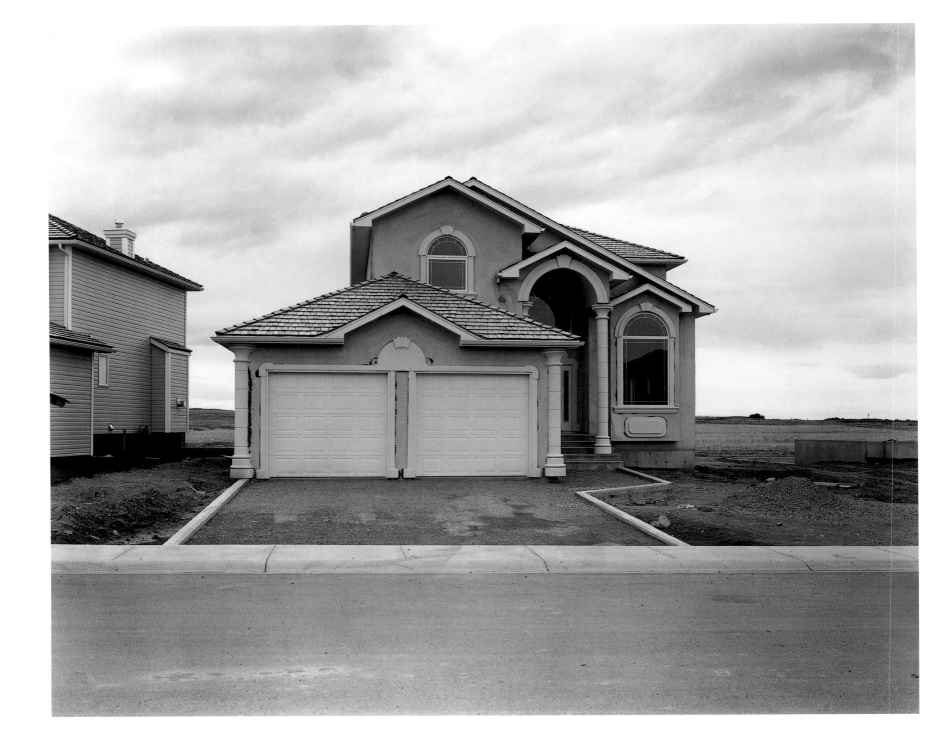

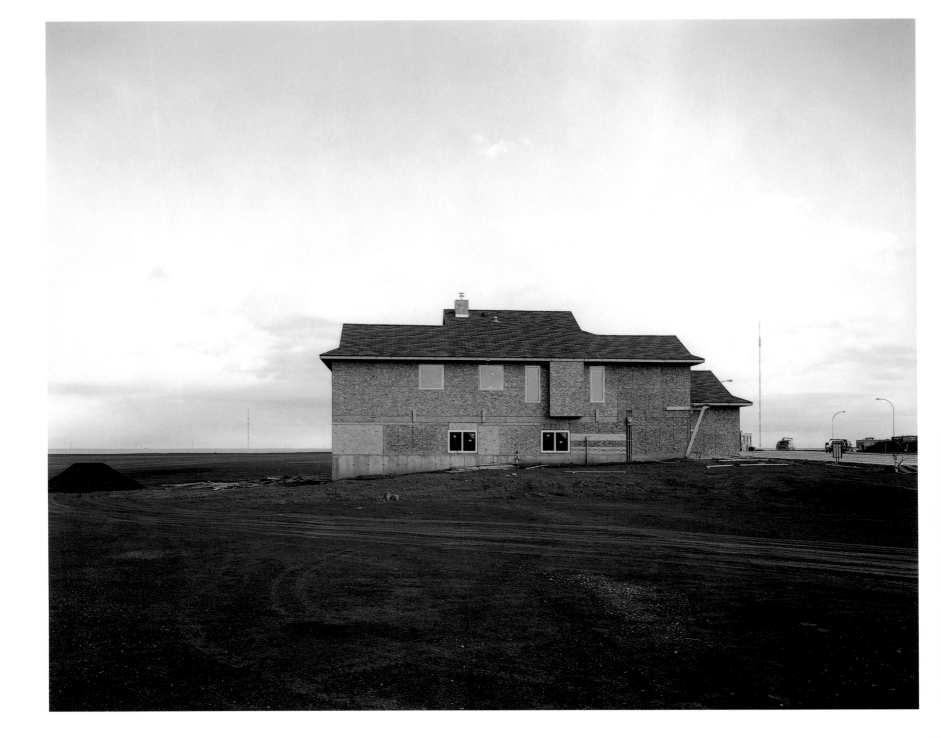

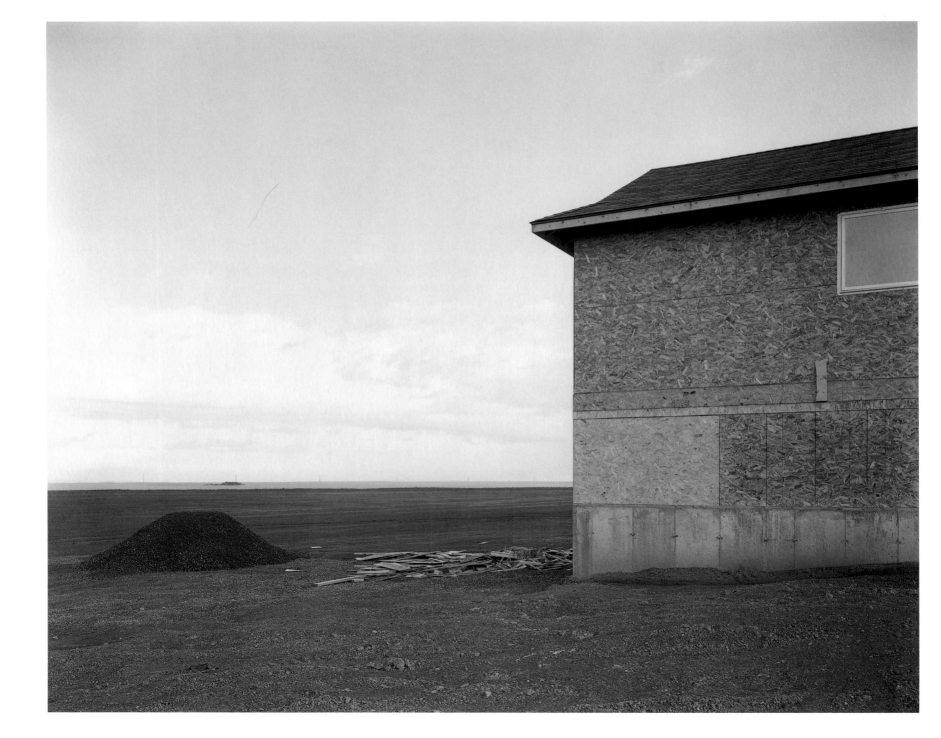

70

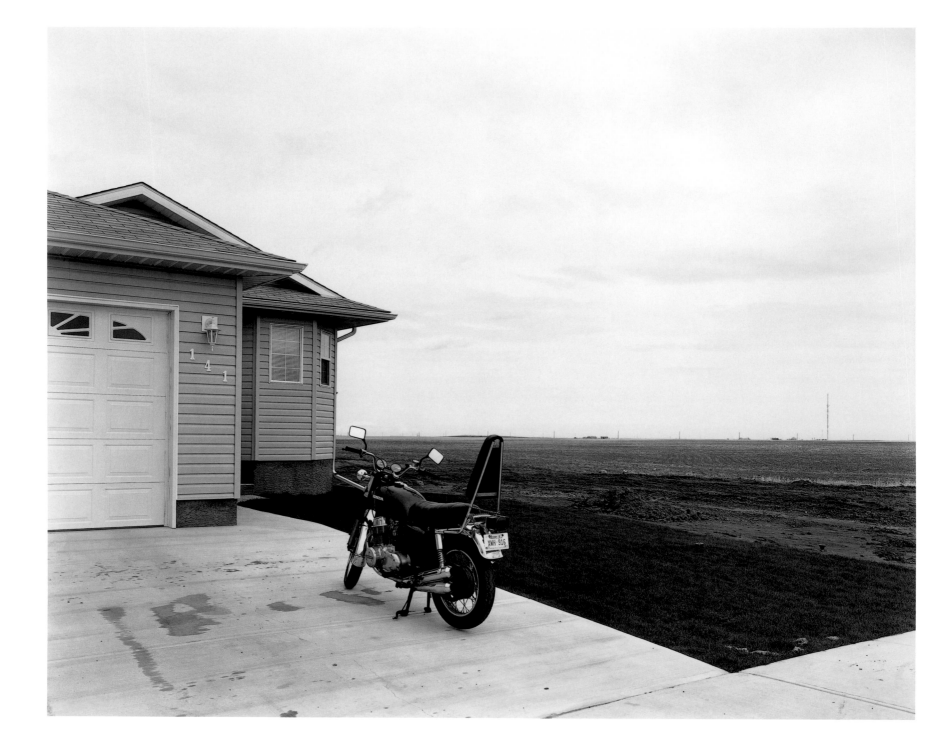

72

PARADISE CANYON AND BEYOND

74

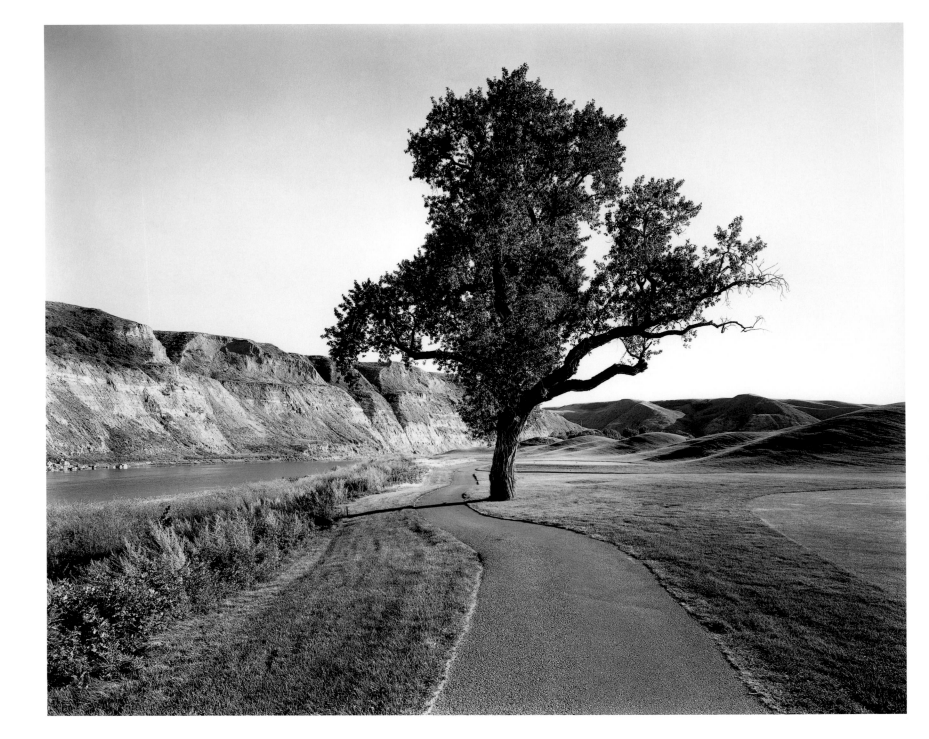

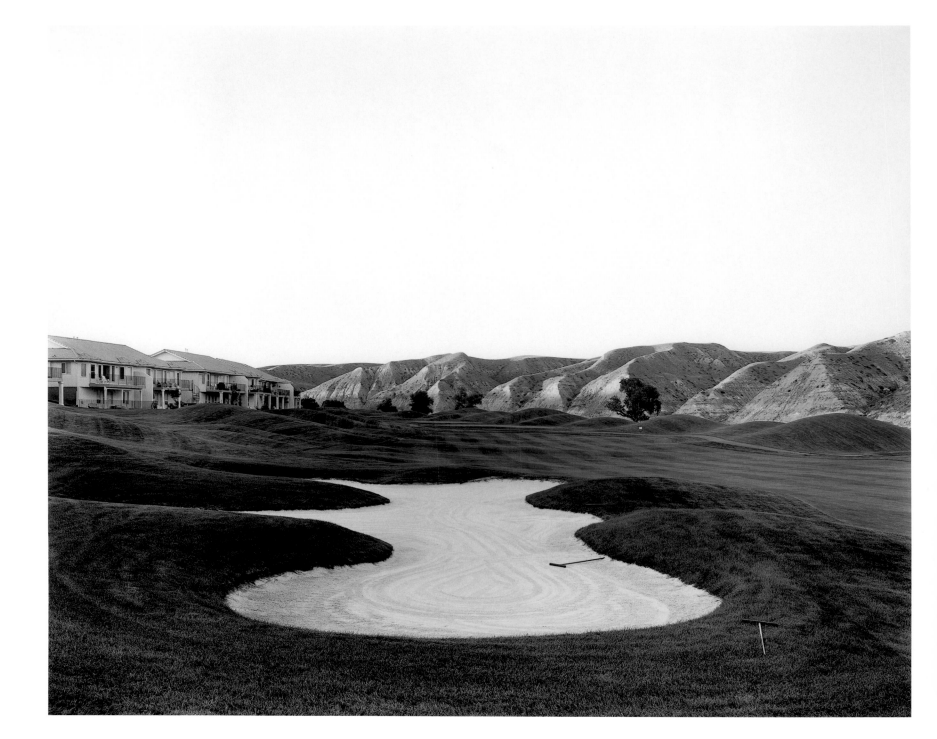

78

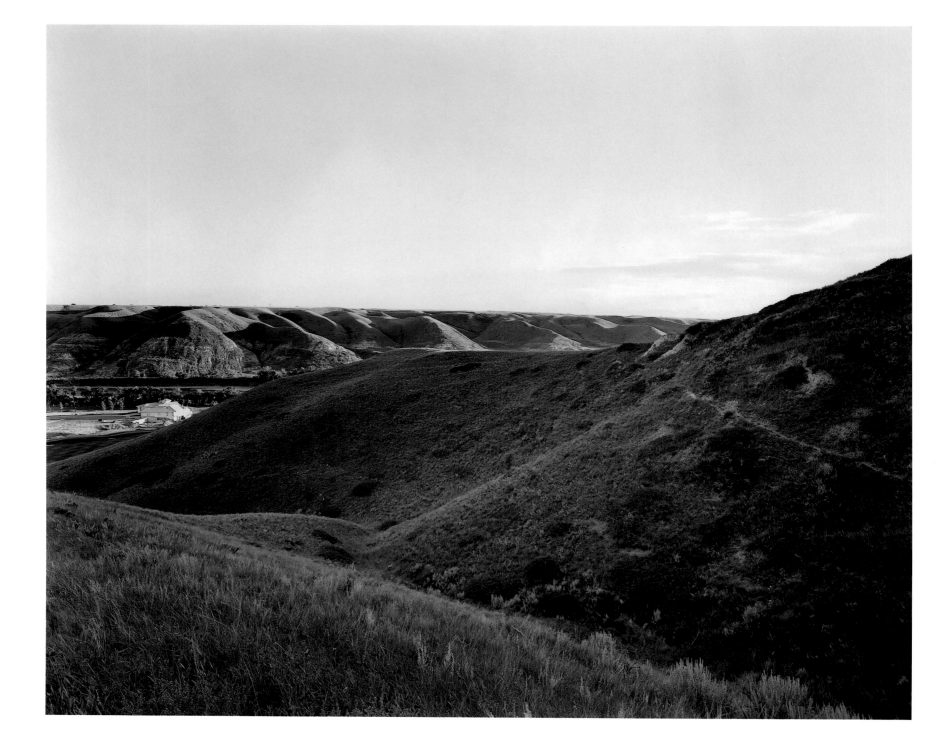

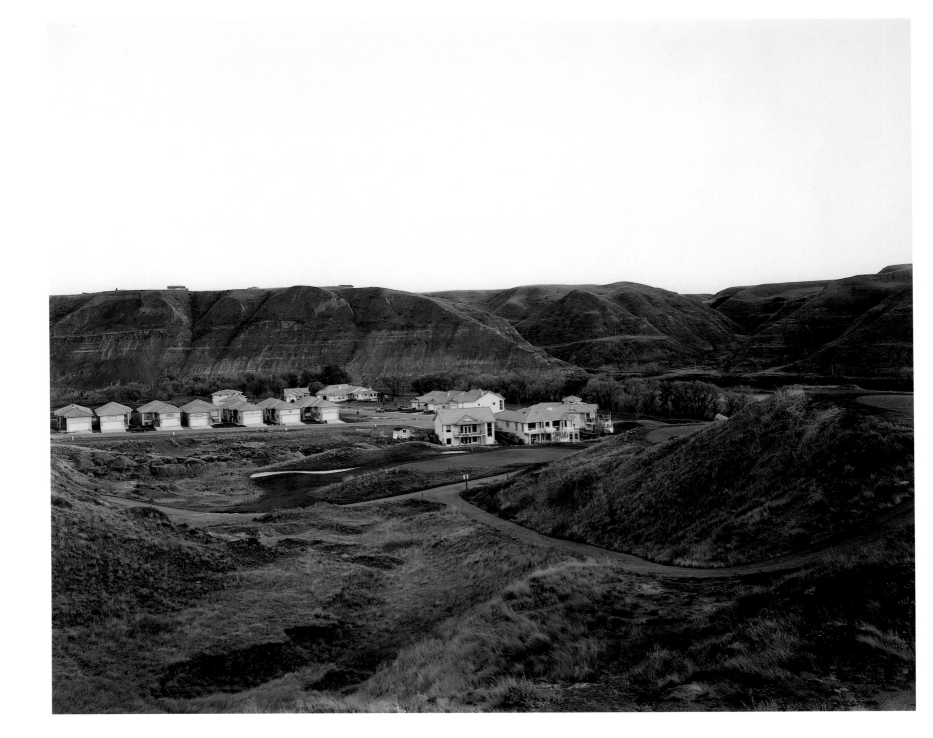

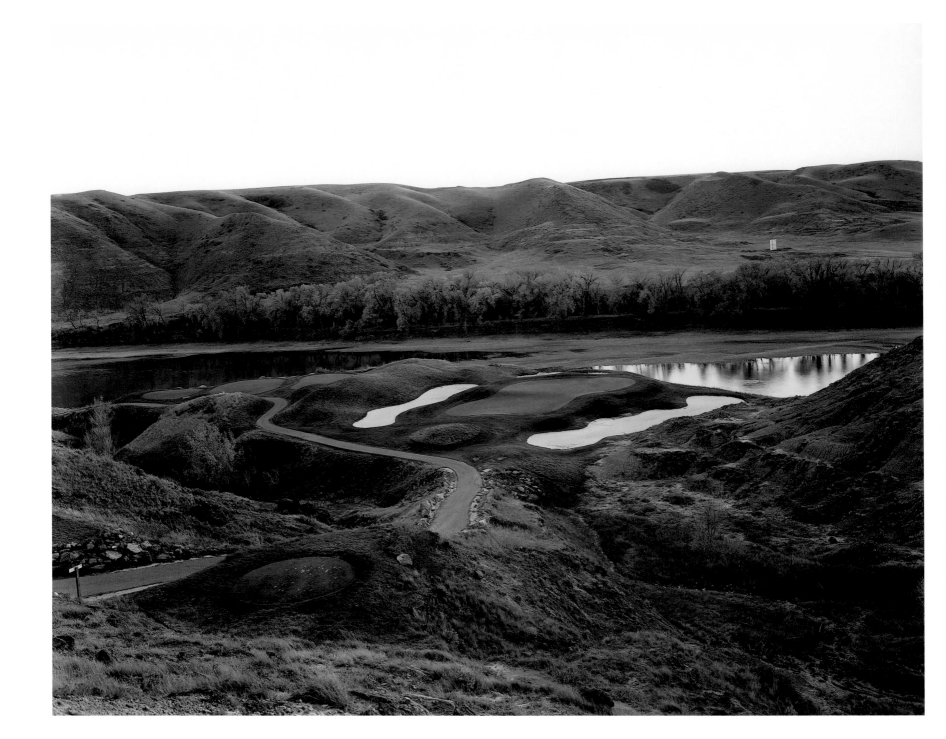

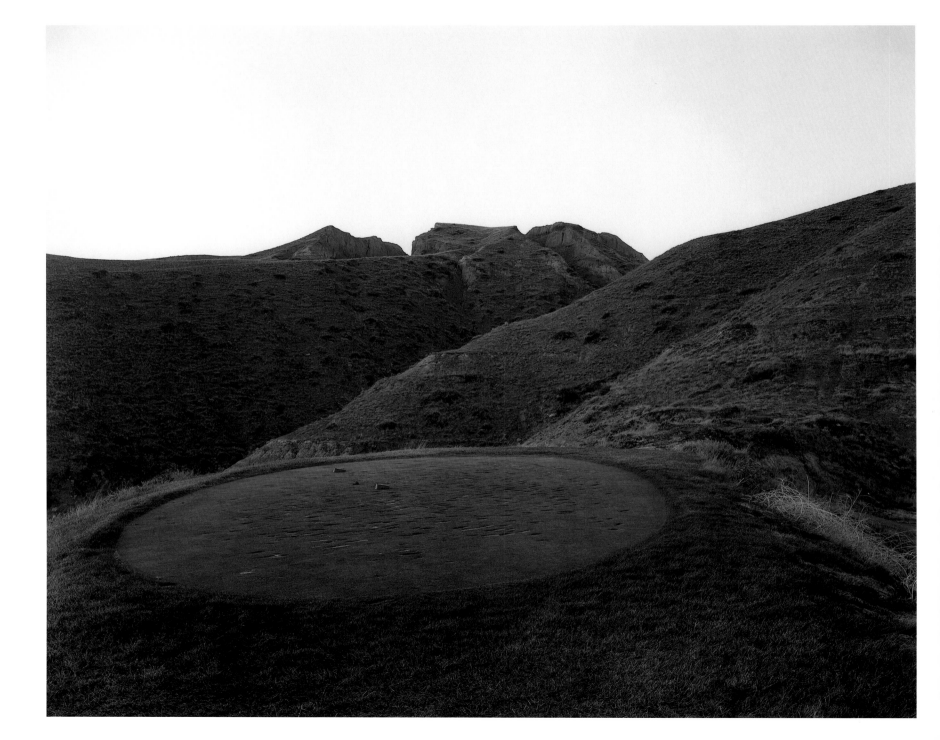

86

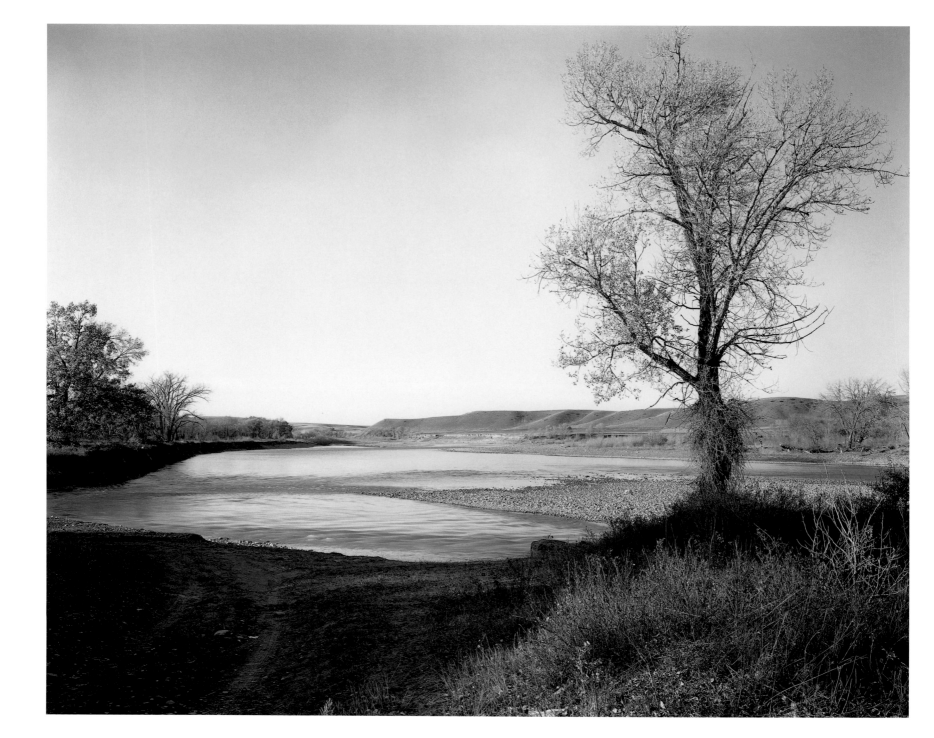

88

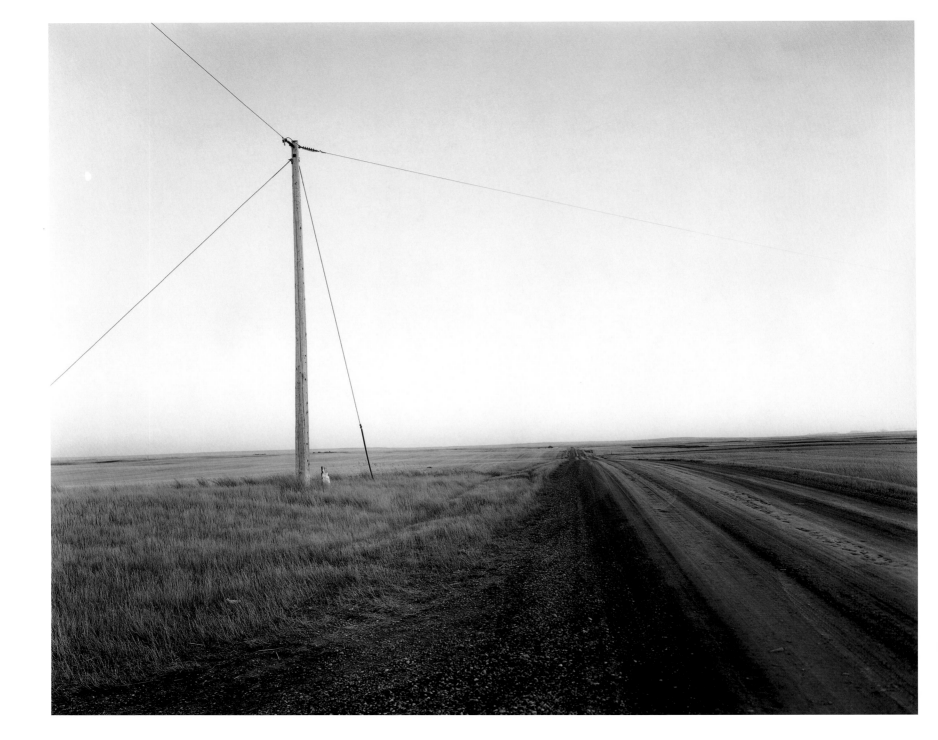

WHERE THE **BLACK** ROCKS

LIE IN THE OLD MAN'S RIVER

92

It is bright spring, and we have been travelling

from Calgary to Lethbridge for three days. The brilliant accumulations of cloud and sun loop us east first, to the Red Deer River cutting out its long swath of badlands between the Hand and the Wintering Hills (on the north side of which we can discern, very clearly as soon as it is pointed out, the hollow of the Old Man's Bed), and then circling around north through Cochrane and the lands of the Nakoda people to the Rockies. The low grey sky begins to whiten with snow; wet flakes splotch the windshield like the splayed hands of spirits that would certainly stop us if the nerveless automata of our wipers did not whip them aside. Gradually we bend west on black, gleaming pavement, lift over foothills and the overcast opens suddenly, very

high, just where the Bow River breaks between cliffs, and there is the immense front wall of mountains repeating itself into every discernible distance, massifs row beyond row both north and south, shining like crimson icebergs in the last sunlight.

At the hot springs on the slope of Sulphur Mountain, snow rims the pool, but the falling snowflakes vanish before they can touch our heads afloat on the steaming water.

Next morning we circle again, but south. Following the Highwood River between the nunataks of the Highwood Pass, and then down to the Sheep River and Willow Creek, south along the foothill valleys of the Porcupine Hills until the Oldman River breaks white beside us through the

Livingstone Gap, curves past the great stones where Napi, the Old Man, played, and over to the Crowsnest River cascading away from all the semi-sleep of coal towns barely breathing and the granite castellations of Crowsnest Mountain thrust into the blue sky as they always have. Then we swing east, past the white, blasted face of Turtle Mountain, fast as the prairie flattens down step by giant step into horizon until I turn off the gravel road I know and there's the house on the lip of the Oldman cliffs; a prairie house not yet strewn east up the coulee by the relentless wind. I find the hidden key and unlock the door. Two of us remain on the deck overlooking the deep bend of the river, the eroded cliffs and gigantic cottonwoods below turning pale May green, thunderheads piling higher over mountains in the west.

"It's really not fair," says the woman from South Africa—or is it Kosovo, or Afghanistan or Sierra Leone or Cambodia or North Korea or Colombia or Bosnia or Iraq or Somalia or Palestine or a country we have not yet heard of in Canada?—this gentle woman says, "It's not fair."

"What?"

"You just drive us around for days over this incredible land anywhere you please, and no one stops you with machine guns hanging on their shoulders and you never have to show papers to anyone or explain a word about where you're going or with whom, and you come down a track to this isolated, empty house and there's no seven-foot steel fence with electrified barbed wire along the top or guard dogs or bars at the windows or bulletproof glass—just birds singing while the river runs and all the trees grow."

"There's a thunderstorm coming, over there, with the wind."

She laughs aloud. Her companion leans out over the balcony rail above us.

"No, it certainly is not fair," he says, into that sudden hush before the wind bends the trees along the river below us with a roar. "To be able to live in one of the rarest places on earth."

And momentarily, all around in this delicate spring, there seems to be nothing at all in the world but weather.

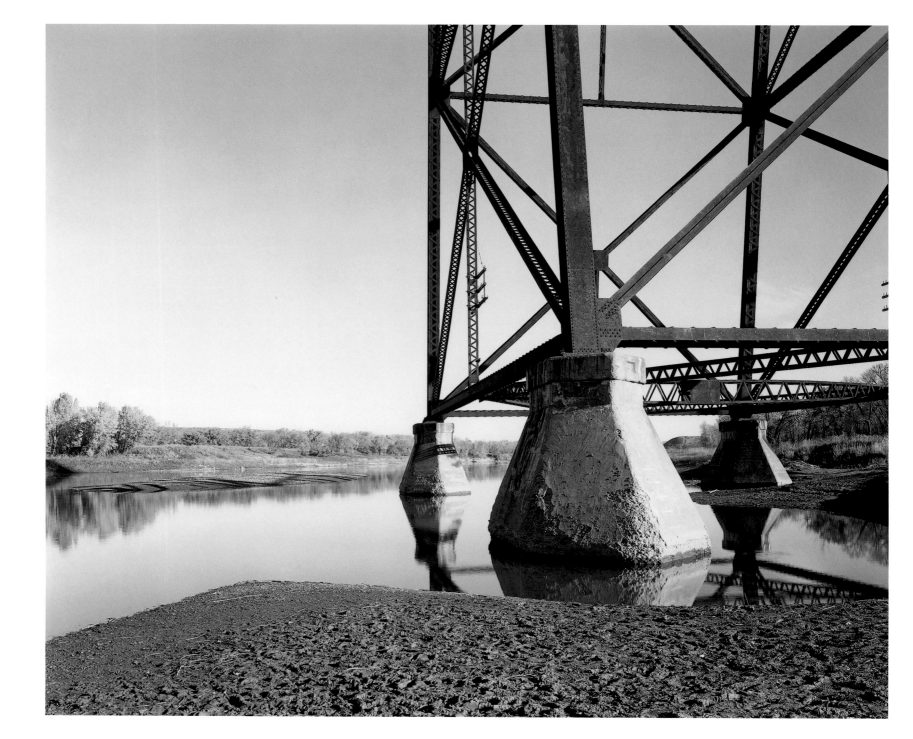

The first time I saw Lethbridge

must have been a late spring Friday in 1947. I read in my sister Elizabeth's Five Year Diary (five narrow lines for each day) that my mother, father, she and I arrived in "our new home" in Coaldale "about 7 o'clock" on Thursday, May 15, 1947, and that next day the same businessman, Mr. Voth, who had come in his car to Saskatchewan to bring us to southern Alberta, "took us to Lethbridge" and we "got some nice furniture."

Lethbridge, the Irrigation Capital of Canada, 1947 population 17,807; it seems I cannot find it in my memory, not that first time. We must have driven from Coaldale on the new gravel of Number Three Highway then being built to parallel the CPR tracks, past the two red Broxburn elevators,

because the old highway route led two miles south from Coaldale before turning west and that would have taken us between the Experimental Station and the 1911 fortress of the Lethbridge Provincial Gaol, where, as Mr. Voth would certainly have told us, fourteen men had already been hanged over the years and no doubt more were inside waiting. Such facts would certainly have remained hooked into me; I was twelve.

As it is, I do remember that I was in the back seat, tight against the right window, and just north of the intersection where the highway bent into the city there appeared for a moment seemingly endless rows of ugly rectangular two-storey buildings. Lethbridge Internment Camp No. 133, as I

did not then know to name it, flat roofs level as the horizon over what looked like double rows of grey posts and close strands of barbed wire, which I had known all my life, of course, but until then had only seen used to control the movement of animals. Prisoner of War Camp, Mr. Voth told us, lots more prisoners in there than people in Lethbridge, maybe twenty thousand of them inside that wire for the whole war, they'd never say exactly how many, men only and fed as good as any Canadian soldier; fed a lot better than anybody else in the whole country, and five of them had been hanged now just before Christmas in the Lethbridge Gaol back there behind the trees for strangling a fellow prisoner who had, it was said, yelled something against Hitler.

Barely five months before, December 18, 1946. Three of the five attempted suicide with smuggled razor blades, but they were patched up and then hanged. One of them, while climbing the gallows, had said in German, "My Fuehrer, I follow thee!" Everybody inside that barbed wire spoke German as exact as printed books, Mr. Voth told us in Mennonite Low German.

The flat camp on the flat prairie at 5th Avenue

North—maximum capacity 12,500 men—was empty and the barracks being torn down when I first saw it, the watchtowers and main gates already gone; the last war prisoners had been shipped back to Halifax and Europe on the CPR and the camp closed, by strange coincidence, also on December 18, 1946. Six thousand POWs, as they were called, from all over the land, had requested to remain in Canada, but not a single permission was granted. Four decades later a professor of English in Graz, Austria, would tell me stories about Camp No. 133; he was a short stocky man who in 1940 at age eighteen was perfect for submarine duty, the "sexiest," as we would say now, of all possible services in the German military. "When we walked down the quay in Kiel, every girl smiled greetings at us," he told me. Sexier and safer than the Luftwaffe, he thought then too (wrongly), leaving the beauty of Austrian mountains for what he discovered was the silent explosive violence of the depths of the sea. On his very first tour of duty their sub was blown out of the water; from a crew of sixty-five, he and five others survived to be picked out of the North Atlantic by the British-Canadian convoy they had been attacking. He told me that beyond the

Government Elevator and the low houses of Lethbridge, where he arrived in December 1942, he could see the crest of Chief Mountain under snow on the southwestern horizon, a mountain like his memory of his homeland, but all around him the circle of open land such as he had never seen or could truly imagine before. "My war was very quiet, absolutely safe on your immense, beautiful Canadian prairie. I never got closer to your mountains. I worked in fields and learned English." When we compared locations, we discovered he and I probably had thinned and hoed the same beet fields, he no more than five years before I, and certainly under the same windy sun.

As I said, I remember nothing about my first glimpse of Lethbridge itself. I read in my sister's diary that while we were buying furniture for our small new house in a store on Third Avenue "we met a nice man," but I do not remember him, either.

What does remain is the pavement the construction crews laid next summer on the highway from Coaldale, west over the crest of land towards Lethbridge; laid down as slowly, carefully, as if they were engendering an unending strip of thick and priceless metal. When in the bright sunlight you looked into the distance over its impeccable black surface, it gradually began to shimmer, then shine in the lifting heat like a revelation of water: when you looked west to the mountains you discovered yourself no longer on land, your feet had been placed on the narrow edge of the world's blue, incomprehensible sea.

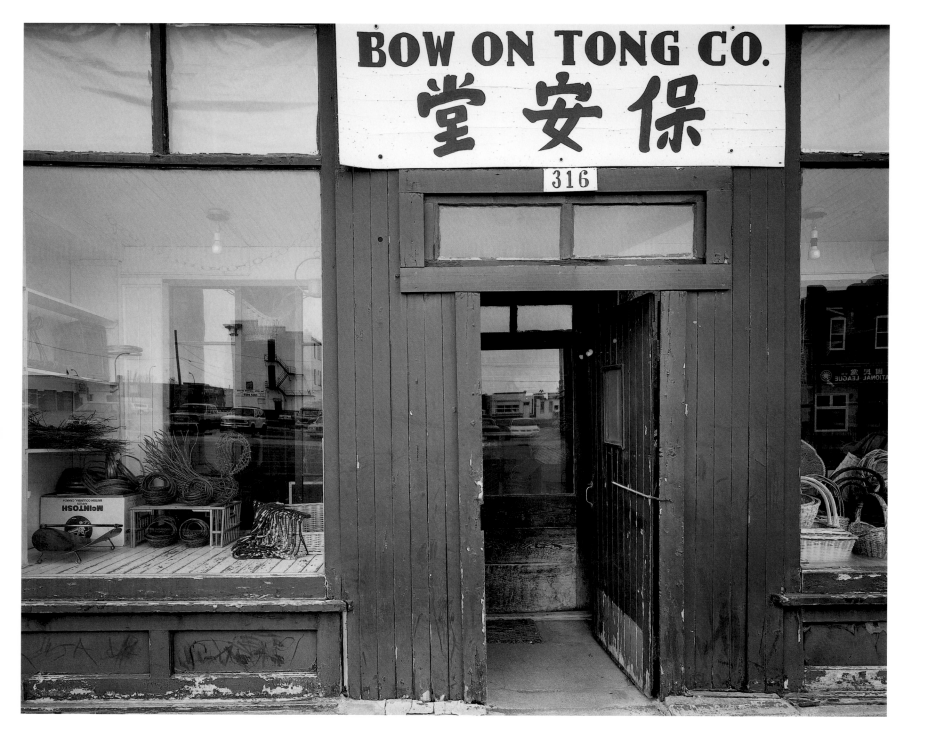

When my parents, my sister and I

moved to southern Alberta from Saskatchewan, the English language changed drastically with the drastic landscape. I knew "slough" and "muskeg" and "poplar" and "spruce," of course, and "saskatoon," but I knew nothing about "coulee," "chinook," "cottonwood," "sage," "cactus." The Native people had been inscrutable Cree, but in Alberta their names carried the blunt aggression of Blackfoot and Blood. The language of lakes and momentary creeks in spring runoff and the swamps stuffed green with bulrushes for the red-wing blackbirds to sway on and nest and all that stony soil which destroyed the back of any man riding his plow deep through the poplar and spruce bush of Saskatchewan became, in southern Alberta, the language of prairie, foothills and mountains, and especially what seemed to me enormous, muddy rivers carving their way through eroded valleys ever north and east towards the ocean. In Saskatchewan I had never lived near a river, could not remember seeing one until I was taken to the hospital in North Battleford to have my awkward, mislocated appendix removed; only the school globe turning under my hand showed me where great rivers ran, and they are hard to imagine from spring creeks, almost as hard as mountains out of poplar hills.

But here a whole vocabulary not only of landscape but also of work faced me: in particular, sugar beets and irrigation. We suddenly lived

beside a ditch running free all summer with thick water flickering past our house and connected somewhere to larger and larger ditches dragged in straight patterns into the flat land until they joined main ditches and finally the Overland Canal and eventually, above us somewhere in the invisible foothills, opened into a lake hidden behind a dam I could for years only imagine. But I always understood: this liquid mud settling out in our cistern, this almost clear water which we skimmed off the top by pail with great gratitude—no need for a wagon hauling barrels, always available and always free—connected us to the high distant snow sometimes visible on the southwest horizon. What I drank from our dipper was the immeasurable gift of the Rocky Mountains.

"St. Mary hits the Oldman just below the Belly."

A water geography of Lethbridge river names I was told with a schoolboy leer; whose sexual implications I then did not understand. Nor decipher why the names were so odd. St. Mary would of course be something, somewhere, Roman Catholic, but why would Paul Robeson in his unbelievable bass sing about not plantin' cotton on Old Man River rolling along through the valley below

Lethbridge? Did it have something to do with the giant cottonwood trees that grew tangled there? But oddest of all, the Belly River—a name, I learned, first given to the entire river system flowing east to the Bow to form the South Saskatchewan because the Atsina aboriginal people once lived here and, through a mistranslation, were called Gros Ventre by the French—but the city-founding English found the name "really unsavoury." The *Lethbridge News* reported in 1900 that the ladies of Lethbridge could but blush when they had to name the river on which their homes were situated, and so, after numerous petitions and a careful study of water volume, the Geographic Board of Canada in 1914 banished the name to a far tributary. The present Belly River begins among the peaks of Chief Mountain in the United States and runs through no city at all, not even a village, and so can no longer be a cause for early twentieth-century genteel embarrassment.

The English petitioned to have a nice English name attached to their rambunctious river, Lethbridge perhaps, to double the use of their own colonial designation, or, better yet, Alberta. Thankfully, the Geographic Board decided that the

provincial use of the third name of the fourth daughter of Queen Victoria was enough obeisance to distant royalty; the board named the river Oldman, the oldest and richest name of all.

Even after ten years in southern Alberta I would have no intimation of the mind-expanding world of story contained in that word, Napi-ooch-a-tay-cots in Blackfoot: "the River the Old Man Played Upon," in a playing field that can still be seen in the foothill wilderness beyond the Porcupine Hills. Napi, the Blackfoot creator and trickster, the Old Man known to the Cree farther north as Wi-suk-i-shak, whose stories would eventually become as evocative to me as those of Moses and Odysseus, Shakespeare and Goethe. What I did know at age twelve was that I had been moved from an isolated bush farm and a single-room log school to sidewalks and electricity and coal mines half a mile deep and sugar beets and libraries with shelves and shelves of books; the world had gone "both so passing strange. And wonderful."

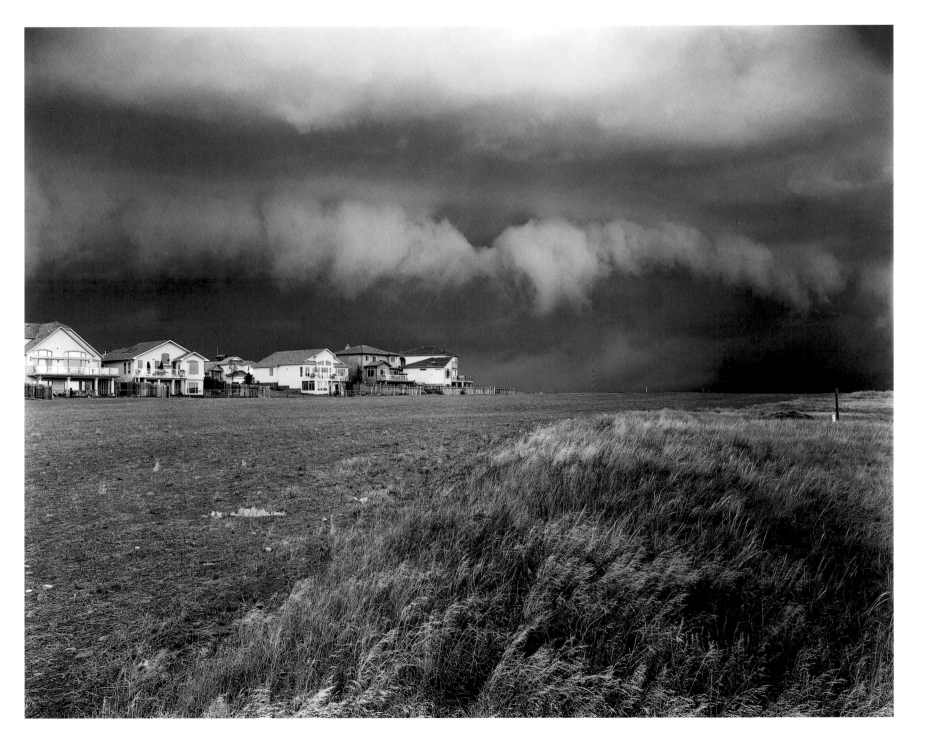

The wind is a sea in Lethbridge,

and usually by noon the tide rises and the city begins to flood. Gradually, relentlessly, with blusters of increasing violence swirling around eddies of teasing, always merely momentary calm, every street becoming a running surf, every strong tree streaming away bent like seaweed in deep current, every building a headland to dive behind for breathing shelter. That's when the denizens of this place surrender their walking—or swimming if you will; they climb into the submarines of their cars and pickups, they power themselves inside steel through the windy seas, though often, caught by the red cross-currents of intersections, they are forced to stand still while shuddering profoundly.

Well, what did you expect? This is a city of the prairie, a word which comes into English from Old French meaning "extended meadow" and whose space is often associated with long light over water. In 1682 Sir Thomas Browne wrote about "the prairie or large sea meadow upon the coast of Provence," and a century later another Englishman noted, "The prairies are very extensive here, natural meadows covered with long grass . . . like the ocean, as far as the eye can see the view is terminated by the horizon."

"Pr-air-ie"—*air,* suspended in a high and difficult, one might say impossible linguistic balance between paired voiceless bilabial and central approximant consonants, and two gentle frontal vowels. Or, fondled and heard in another way, "prairie" becomes two words, "pra(ye)r" and "air(y)," their bumpy head and knotted tail strung

inextricably together—to create what strange amalgam creature, what improbable verbal lion, snake, goat and eagle chimera?

Strangely enough, in the Judeo-Christian and Arabic traditions many of us were born into, the movement of air we call "wind" is the most evocative image for the divine; that spirit of God which breathes life into every creation and which inspires (quite literally, "in-spirits" or "breathes into") all creatures with powers to help them achieve their utmost, their most exalted desires.

Prairie: a landscape of airy prayer indeed.

There can be no doubt about it: after a lengthening spring or summer day of walking in the wind, I know that I have been breathed into. Whether I want to or not. And for the first time I comprehend why the city climbed up out of the deep, protective Oldman River valley and, despite its indenture to coal, built itself large on the unbounded and treeless prairie lying open to the distant mountains: it wanted the full blessing of the wind.

To live in Lethbridge is to be perpetually inspired.

Within the present city boundaries

of Lethbridge lies the site of the last and one of the largest battles ever fought between aboriginal peoples in North America. It began at dawn one day in late October 1870 near Fort Whoop-up, built by American traders from Montana only that summer, when a huge war party of at least five hundred Cree warriors with their Assiniboine allies attacked a small Blood encampment on the Belly (now Oldman) River. The Cree and their allies had walked and ridden south some two hundred miles from their usual lands to avenge the killing of their aged peace chief, Maskeptetoon ("The Broken Arm") by Blackfoot the spring before; however, unknown to the attackers, there were several larger camps of the Blackfoot Confederacy in the vicinity,

and their warriors, armed with the latest Winchester and Henry repeating rifles and Colt revolvers traded from the Americans, quickly came to fight with the Bloods. Together they drove the attackers, who had by then destroyed the small Blood camp, back into retreat over the open prairie and into the long river coulees, and eventually down into the deep valley which today lies between the city centre and the university suburb of West Lethbridge. After four or five hours of fighting, they say, forty Blackfoot were dead and fifty wounded; the Cree escaped total annihilation only by leaving three hundred of their dead behind.

After these events the Blackfoot, for whom, like all oral peoples, geographical place names often

became the historical record of their living past, began to call the Oldman River valley at that spot Assini-etomotchi: "Where They Slaughtered the Cree."

"Slaughter"—a horrific word, with none of the echoing dignity and heroism whites attach to such killing encounters when they name them "battle." But it strikes me as an honest word here: slaughter, on a scale impossible for the prairie peoples until Europeans arrived with their horses and guns.

It is an easy walk, now, to get an overview of the field of slaughter. Stone markers and explanatory plaques have been erected at various spots; historian Alex Johnson has collected all available eyewitness accounts into an excellent booklet, *The Battle at Belly River,* first published in 1966 and reissued in 1997 as *The Last Great Indian Battle,* with the added findings of an archeological dig to identify the exact western riverbank coulees, just north of today's Whoop-Up Drive, where the Cree and the Assiniboine for a time tried to make their last stand. They were in one long coulee leading down to the river, trying to cover their retreat with musket fire and arrows but—from the parallel coulees on either side of them, the Bloods and Siksika to

the north, the Peigans to the south—they were being raked by the bullets of repeating rifles. In the 1997 book the precise evidence of musket balls and shells and bullets and a single iron projectile point over three inches long, uncovered at the various sites, are exactly mapped, identified and listed. And finally, though building Whoop-Up Drive covered the battle site at that spot, two commemorative parks have been established to preserve most of the vital geographical places: Bull Trail Park in West Lethbridge which includes the three battle coulees, and Indian Battle Park in the valley where the Cree and their horses fell from banks and cliffs into the river, staggered through the water to die in the open glades and under the massive cottonwoods.

All that a hundred and thirty years of facticity and forgetting can reveal about this inter-tribal violence—a typically human revenge disaster of accident and treachery, racial prejudice and hatred, courage, ambition, loyalty, overwhelming brutality and heroic as well as grotesque death—as much evidence as is still findable has been carefully gathered. Though as many as three hundred and fifty men, and certainly some dozens of women and

children, died in 1870 at Assini-etomotchi, in the European tradition of inter-tribal violence the Battle at Belly River is, to put it very mildly, not large. To encounter a memory of a typical nineteenth-century slaughter between so-called Christian peoples, one need only fly to Brussels, Belgium, and make the short drive south to the pleasant grain fields surrounding the village of Waterloo. There, on a painted, three-dimensional panorama one hundred and ten yards by twelve, you can today see in one continuous horrified stare how "heroically" more than sixty thousand men and ten thousand horses were destroyed in the course of one Christian "day of rest," Sunday, June 18, 1815. Not to speak of the wounded and the maimed, the mentally shattered.

The facticity of even the largest aboriginal battle in 1870 comes quickly to its end; there can be no archival government lists of men and supplies. For years Blackfoot men must have sung their battle exploits in the warrior lodges; around their family winter campfires, many would certainly have told stories about those river cliffs and coulees "where they slaughtered the Cree"; but no contemporary written accounts survive—in the highly unlikely

event they were made. What writings we have are a few memories filtered through decades of time and bundled together by white translator-recorders using whatever they could command of Blackfoot and English idiom. Mike Mountain Horse (1885–1964) wrote a fine book called *My People, the Bloods* (1979), and it does contain a brief chapter on "The Great Battle," but he gives no personal details of what his grandfather or father—both leading warriors in the battle—might have told him of their experiences on that bloody day. So perhaps, for us, only informed imagination remains.

In *The Temptations of Big Bear,* a novel I wrote thirty years ago, the protagonist Big Bear, one of the historical Cree chiefs who fought at Belly River, sings a story of how his third son, Twin Wolverine, fought that violent battle in his own way. The story is, of necessity, a long lament, and as Big Bear nears the end of it he remembers the Blackfoot had so much firepower, the Cree could no longer hold their position:

> Finally we had to crawl from our coulee for the river. There was nothing to be seen but smoke and at first they didn't follow, but soon they

charged so hard some of us had to retreat down against a ridge which broke off into the river below. Here our few horses left started breaking their legs, the river was deeper against the banks and sucked warriors under when they fell into it. Bear Son was screaming as the grey horse he had taken at the Blood camp snapped both its front legs trying to stick to that sheered-off cliff, "The river's all blood, blood!"

On the edge of the coulee behind us the two Sutherland brothers fighting with us screamed in a white language no one understood and when their legs were finished they lay on them and tore Bloods apart with their teeth and knives, but their yellow hair came free at last and they had to be left there, above the river for the Blood women to finish cutting what was left of them. We were down and through the river by then, some of us, and the Blood warrior Mountain Chief had stabbed Rabbit Head between the shoulders while he was crossing . . . and then Bear Son had him by the hair and drove his knife into his back; but Mountain Chief was still singing his power song,

"My body will be lying on the plains,

The guns, the knives they hear
Me!"

and his war bonnet had worked down his neck and the knife stuck in that when Bear Son drove it into him. That Blood saw the handle sticking out behind himself and grabbed it and then the knife drank Cree blood, deep, and Mountain Chief pulled the knife out and stabbed again, still singing, and then held the knife up to Sun, there was nothing to see but horses' teeth foaming, coming at us up out of the river. . . . And I said to my sons, the two that were left, "Your brother Bear Son lies by the river." We had nothing but a few arrows left, and stones. We were throwing pieces of the black rock that burns at the horses as they kept charging us under the trees.

Little Bad Man stared at me, but Twin Wolverine, suddenly, started to walk. He still held his musket and hadn't fired it once that day; he hadn't opened his mouth and his knife was stuck in his belt with not a drop on it. But now he sang, loud. The song he sang was Coyote's, which we had heard the night before at Little Bow Crossing warning us about the battle, not to go into battle but we wouldn't

listen, only Twin Wolverine who walked out into the clearing toward the river where shadows already reached out black from the cliffs. He was walking into those warriors hot with our weapons and our blood and it seemed to me that I had dreamed this somewhere, before, and might dream it again someday when I was very weak. A Peigan wheeled, charged him and I saw my youngest son kneel and aim and pull the trigger and that warrior flew up arms and legs, splattered to the ground and the horse galloped on; another rode at him. He had left the musket where he knelt to shoot and as the Blood came on a beautiful sweating black horse Twin Wolverine ducked aside, the warrior was loop-ing over and there he lay, knife through his throat. All the time my son was singing the new song Coyote had lent him, and all those warriors with Mountain Chief stopped then, not riding at him and holding their guns in front of them as they watched him walk without a weapon in his hands to the river and lift the body of his brother Bear Son up on his shoulder and turn his back to the sun and come between them to us still singing and the whole valley there quiet at last, hearing that.

Today you can park beside the cairn in West Leth-bridge at the top of Bull Trail Park and walk down the long battle coulee ridges, walk various trails in the dry cactus earth, looking down either right or left to where warriors once crouched with their guns, walk down to where the cliffs drop sheer into the river. Below you, north over the bent water, where the Cree horses broke their legs and fell, you will see the eroded black heaps of earth marking Nicholas Sheran's first coal mine. You are standing between Whoop-Up Drive Bridge to the south, curving low over the river, and the CPR High Level Bridge to the north, a thin steel line from cliff to cliff. I have stood at that spot only twice myself, and talked to no one there, so I do not know whether, between the endless auto roar of one bridge and the grinding thunder of a possible long train crossing the other, anyone has ever again heard Coyote, singing.

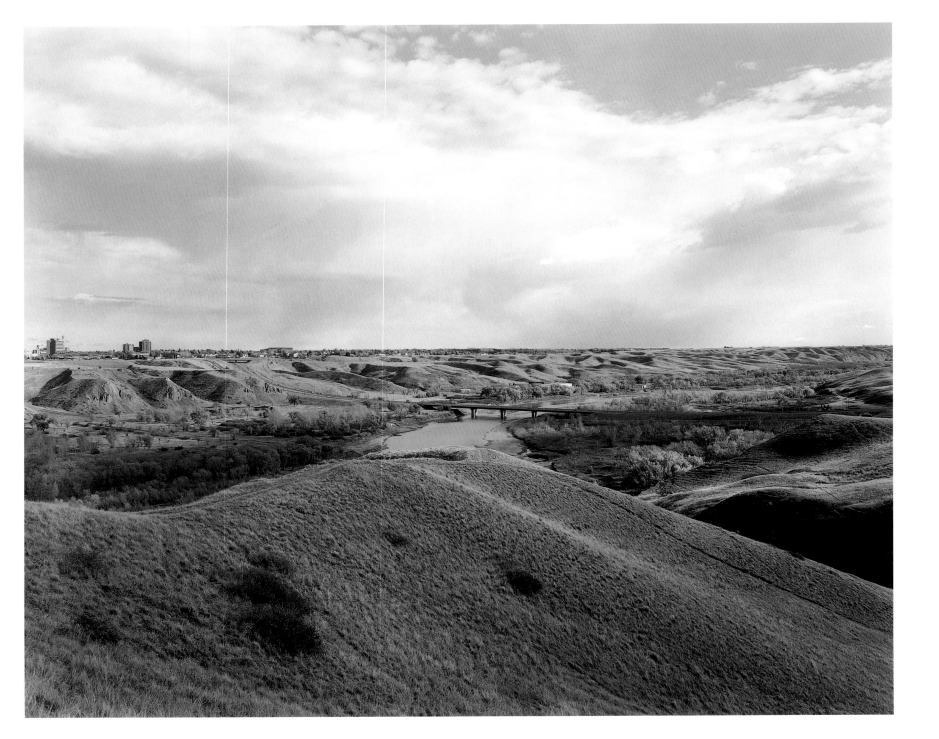

Lethbridge is not named for its bridge,

though it might well be, since the High Level Bridge of the Canadian Pacific Railway is, with the brilliant exception of the University of Lethbridge which architecturally echoes it, the most memorable structure in the city. The Blackfoot, Nakoda and Cree peoples had already, in their various languages, named the river valley at that place Black Rocks, and the first English name reflected that: the American traders named it the Coal Banks because Nicholas Sheran dug the first drift coal mines there as early as 1872. So why "Lethbridge"?

In 1882 Sir Alexander Tilloch Galt (1817–1893), a Montreal politician and land developer who was also Canada's High Commissioner in London, organized the North Western Coal and Navigation Company, which contracted to supply coal to drive the transcontinental CPR then being built across the prairie. One of his London backers was the wealthy bookseller W. H. Smith—bookstores named after him still exist, even in Canada—who interested his friend the publisher William Lethbridge (1825–1901) to help him finance the distant Canadian coal scheme; shortly after, Lethbridge was named president of the development company. That long-faced English gentleman with his narrow nose, curly hair and full round beard was never near the prairie, nor did he ever make the slow sea voyage to Canada; so why was the city not named Galt after Sir Alexander? Or for his son Elliot Torrance Galt, who travelled the prairie far and wide on horseback

and first recommended that the coal on the Belly River be developed; who with his family lived in the splendid house they called Coaldale among the cottonwoods and mines on the river valley flats for some twenty years, expanding those mines and building riverboats and railroads and irrigation systems and farming settlements? Indeed, if some London financier who held shares in the company (there were soon more than thirty English investors) was to have the honour of his name attached to a spot on the unknown and limitless Canadian prairie, why not choose the banker Edward Crabb, who in 1891 was the largest single shareholder with one thousand five hundred shares, two hundred more than Smith and Lethbridge combined?

Galt: since 1827 there had already been a Galt in Ontario. And if Victorian ladies blushed to say they lived on the Belly River, as they evidently did, then what could possibly be said for living in a town named Crabb?

Naming a place in what, to a European, seems to be a "new and empty" land can be a complicated affair; as North-West Mounted Police Inspector Ephrem Brisebois discovered, to his rage. In 1875 he and his detachment built a police post where the Bow and Elbow Rivers meet, and he simply named

it after himself; but NWMP Commissioner James Macleod, who had not hesitated to name the post he built after himself and had allowed Inspector James Walsh the same privilege in the Cypress Hills, Macleod cancelled Fort Brisebois because, among other things, like Brisebois's personal insubordination, he felt it was really too awkward to pronounce. As was often done with French names, it might have been translated into something easier, like Fort Breaks Wood or, with a bit of licence, Fort Breeze in the Timber; we do have unique prairie names like Medicine Hat and Moose Jaw, even Tete Jaune Cache. But when a dour Scot controls naming, we're sure to be stuck with that of his ancestral estate "back home"; in this case, Calgary, on the tiny Isle of Mull in the Hebrides.

So the dour Scot Alex Galt, who doubtless knew the value of memorializing his shareholders, gave the banker his small due by naming a street on the 1885 town plan as Crabb (the present 6th Street South), but labelled the town he foresaw with a Devon publisher's name, Lethbridge. The largest city in Alberta not begun as a fort: that is, as a walled or palisaded settlement of a few apprehensive Europeans trying to keep the wilderness they feared, wildness in its myriad natural and possibly

savage—especially savagely human—forms, somehow at bay. No, in 1885 the wide shortgrass plain where the Alberta Coal Company Railway ended on the cliffs high above the thick black seams of coal eroded bare far below them was laid out as a wholly owned company town with a geometric grid of streets from Baroness Road (today 1st Avenue) to London Road (7th Avenue), and Galt Street (Scenic Drive) to Westminister Road (13th Street). In this staggeringly bare world of light, perpetual wind, horizonless land and gaunt dryness, where the most cheerful flowers were briefly blooming cactus and water at best a distant line of muddy river buried in a wide valley, the names of home helped anchor the newcomers.

The only town in Canada named after a publisher. As a writer, I like that.

And, as one might expect, the publisher's name (thank goodness it wasn't erased later, like the street names, into something Scottishly orderly like No. 3 City) persists with wider, intriguing possibilities. Whatever Mr. Lethbridge's family history may be, *leth* is an obsolete Old English word meaning "hatred" or "ill will"—modern "lethal" derives from it—and if we consider that prefix a bit more we can further find Lethe, the river of forgetful-

ness in the Greek hell of Hades, or *lith,* meaning "stone." Leth-bridge, translated as Stonebridge? Bridge of Hate? Bridge Crossing to Hell?

Such wordplay is best left to poets; hopefully those with a sense of comedy. Beyond any "leth," the "bridge" remains fixed, and today in the centre of Lethbridge a tremendous bridge literally exists as a stunning physical fact. Galt could not have imagined that fact when for whatever, doubtless Scots practical, reasons he chose the name he did for the town he needed to build if he was to make money for his shareholders—coal needs miners and miners need houses and companies need indentured families who will recirculate the money they earn back into other company businesses—nevertheless after 1909, when both namer and namee were long dead, how strangely and evocatively appropriate the name became.

The enlarged 1993 edition of Alex Johnson's book *The C.P.R. High Level Bridge at Lethbridge* (Johnson is everywhere when you read about city history) tells the story of how this improbable steel viaduct bridge was constructed. Beginning with geological formation drilling (November 22, 1906), the book presents detailed information and a startling picture album on every aspect of the work,

from pouring the concrete blocks which would support the bents in that geometry of steel reaching out into the vast space of the valley—a steel spider's web slowly shaping itself in air 314 feet above the river as the erection traveller, with its eleven miles of cable to lower steel girders into place, crept forward over the valley on the piers already riveted in place—to a picture of the last steel girder fitting perfectly into the west abutment 5327.625 feet from the east abutment, lowered into place on June 22, 1909. This final photograph even reveals two workmen jumping to the ground as the girder is lowered, and the caption notes that "this action terminated their employment with the contractor."

Strangely enough, both the river and the antediluvian coal declared their fixed opposition to the bridge in unmistakable ways:

One of the wildest and heaviest Oldman River floods in recorded history ripped through the valley below Lethbridge, submerging it from bank to bank, in June 1908. It tore away the concrete forms and all the substructures of the bridge not already anchored deep in the earth and knocked out the coal-burning power plant that served the city.

Barely had the river receded when the contractors found that bridge piers 21N and 22N were sinking. After digging a shaft between them, they discovered that the piers had been built on the long-abandoned diggings of a drift mine from which dangerous coal gas arose. On July 15 a ten-year-old boy from the valley houses nearby climbed down to play on the timbers of the temporary shaft; he was overcome by the gas and collapsed on the beams. Two workmen who tried to rescue him were also overcome; they fell off the beams to the bottom of the shaft and were dead before they could be brought out. The boy, who had not been working on the bridge but simply playing there, lived.

Of course, mere nature has never, anywhere, ultimately stopped the CPR from buckling its double-steel belt tight over the landscape of Canada. Exactly a year later, in the afternoon of the day when the last girder was fitted into place between piers 65/66 and the concrete abutment on the western river cliff, one hundred Lethbridge residents standing on open flatcars rolled across the bridge.

They found themselves so high, they were looking down on the backs of soaring eagles.

"**Lethbridge was happiness,**"

novelist Joy Kogawa tells a conference audience on "Dilemmas of Reconciliation" in 1999. "A city with restaurants, stores, Woolworths . . . "

She is talking about how a Canadian child of Japanese ancestry experienced World War II, particularly her memory of her family—her father was an ordained Anglican minister—being forced out of their home in Vancouver where she was born, and how at the age of six the mountains and forests of Slocan, B.C., surrounded her, and, a few years later, the seemingly horizonless sugar beets under a staggering Alberta sun. "To come into Lethbridge for a day," she says, "from the shack on the farm where we lived, to walk on a sidewalk again, that was happiness."

The not-really-so-innocent sidewalks of Lethbridge, which was once so strongly British by 1916 that twenty percent of its population had enlisted for World War I military service, the highest percentage of any city in Canada. But in 1943 little Joy Nakayama (as she was then) had no idea that her fellow Canadians of Asian ancestry, the Chinese, had once been forced by city bylaw to live and allowed to have businesses only west of 4th Street in what was called the Segregated Area, a space so limited "the Celestials" as the *Lethbridge Daily News* wrote slyly on December 23, 1910, might "want to set up business in the coulees." That particularly offensive bylaw was rescinded in 1916, but the area remained predominantly Chinese, and the same

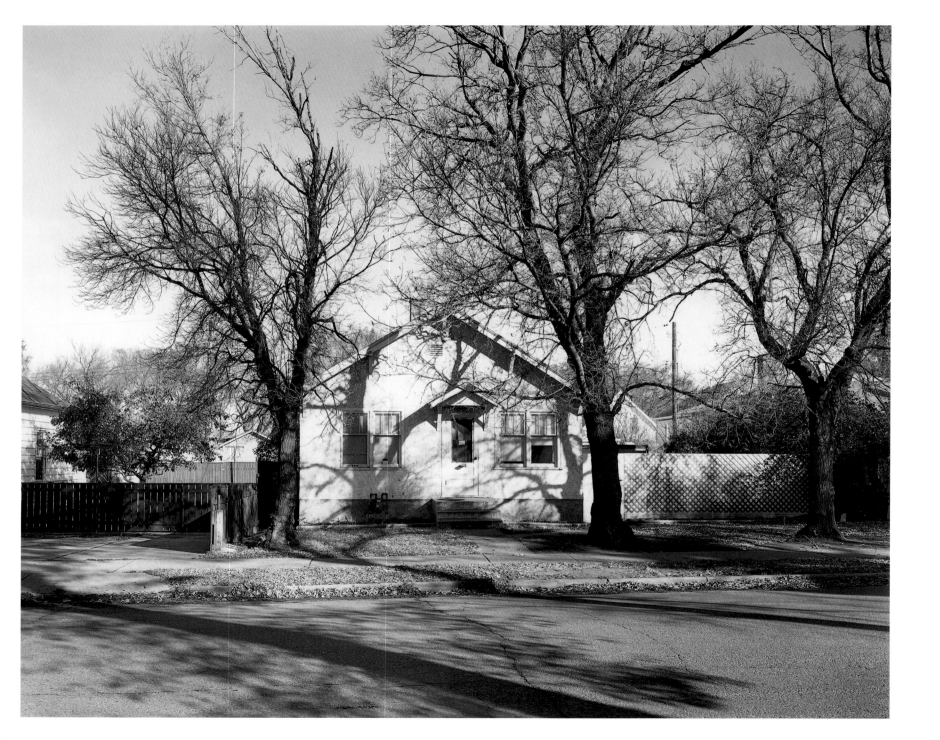

part of the old town core quickly became the home for prostitution when, after 1918, the bordellos on the Point, which had originally moved up the coulees from the Bottoms of the river valley, sidled ever closer to the "nice, clean, English" business district along 5th Street. The amazing range of prostitution in Lethbridge is vividly described in a chapter of James Gray's *Red Lights on the Prairies* (1971), though the subject seems large enough to deserve a book of its own. The Lethbridge Lodge Hotel now blocks the site of the Point, but if you walk around the building and across its parking lot and west over the bulldozed flat between widening coulees to the viewpoint overlooking Fort Whoop-up and Indian Battle Park, you are essentially walking down the centre of the old bordello street. By the early fifties, when I first drove south along 2nd Street, the magnificent panorama of the Point and its tangled vivid history was buried under official forgetfulness and the rusting wrecks of an automobile graveyard.

This intersection of restricted Chinese and officially tolerated vice, which was so beneficial for all the "proper" local businesses that it received strong and continuous support from all the "Chris-tian" businessmen around Galt Gardens, was most active along 3rd Avenue and 3rd Street South, the block now occupied by the Provincial Courthouse. Its growth "ushered in," as Johnson and Peat wrote in *Lethbridge Place Names* (1987), "Lethbridge's golden age of prostitution, as the district operated in wide-open fashion until 1944." The services the area provided, not only for solitary coalminers and cowboys and laundry workers and settlers but also, as numerous reports declared, "for the married men of the city," were regulated by city council and enforced by city police as discreetly as they could, but for obvious economic and taxpayer reasons they would not, as at various times the local churches tried to insist, be bylawed out of existence.

Nevertheless, in March 1942, Lethbridge City Council could, and did, pass a racially discriminatory, paranoid bylaw about Japanese Canadians evacuated from the West Coast, a law even children had to know about. It stated "that any Japanese moved [into the district must] remain domiciled on the farms to which they are allocated, and that they will not move and reside in the City of Lethbridge." This really meant that certain

Canadians could neither go to school in the city nor find employment there between the beet-working seasons.

But through the fortunate accident of our late births, when Joy Nakayama and I were growing up and attending the same school in nearby Coaldale, this Lethbridge history of racial prejudice was, at least officially, over; by 1947 the Segregated Area was no more and the bylaw against Canadians of Japanese ancestry had been rescinded. For me, as for Joy, the city spreading east across the prairie from the lip of the Oldman River cliffs and coulees seemed merely wonderful. A lake park for swimming surrounded by huge trees—its cowboy name, Slaughter House Slough, long forgotten; whole blocks of great early-century houses with tall pillared entrances and wide verandas that swept around two entire walls, their fretwork gables and round turret windows fit for Sleeping Beauties and, most amazing of all, roof shingles laid in wavy lines bending and curving around each other over rounded dormers; a steel bridge from beneath which you could see crossing, as through clouds, the steam trains of the almighty Canadian Pacific Railway (which had carried my penniless family of refugees halfway round the world from Communism to Canada on a simple Mennonite promise to "pay our debt"), enormous engines shifting and bumping freight cars in the railroad yard under blasts of steam and disappearing to sleep in their roundhouse dialled by rails turning like the hands of a clock; the corrugated-steel tipple and water tower of Number Eight Coal Mine rising above the distant cliffs of the Oldman River where the thin Bridge closed into its vanishing point and where our high school class once dropped two thousand feet, they told us, into the earth, to discover blind horses walking down long black tunnels there and black-faced miners with lamps on their foreheads who knelt on rock and, as it seemed in the darkness, prayed with shovels and picks before the gleaming broken face of a coal seam; and the towered, clocked Canada Post Office mirrored by the Marquis Hotel whose magnificent lobby no child could dare enter, and the Trianon Ballroom where a dutiful little Mennonite kid did not even want to imagine what went on; McGuires Mens Wear full of clothing probably for English lords and Leo Singer's Mens and Boys Wear on 5th Street where my mother once bought me a high-necked knitted

shirt (T-shirts did not yet exist by name), and—beyond everything else—the Lethbridge Public Library.

Surrounded by the shorn grass and splendid trees of Galt Gardens, a large brick building devoted totally to books.

The yellow school bus that brought shoppers from the town of Coaldale every Saturday parked at the corner of the gardens, 3rd Avenue and 7th Street. My mother and sister would go shopping and I, after studying again—Don't Touch!—the astounding display of magazines and newspapers at the Club Cigar Store (I did not know it had once been part of the Hotel Coaldale) while devouring a five-cent ice-cream cone, I would cross 3rd Avenue, pass the smiling man in the corner kiosk with all his golden popcorn, and walk up the granite and limestone steps into the library. If the disorder which in 1933 caused the Carnegie Foundation to name the Lethbridge Library the most poorly planned facility it had ever helped sponsor—truly a "librarian's nightmare"—that handicap, if it remained in 1948, was completely unnoticed by me. Thousands of books on open stacks, to reach up for, to take in your hands, to hold, to open, any-

where in their hundreds of pages. And read. When the Senator Buchanan addition was built, I sat in the alcove in the tall narrow window facing east and read on.

So many, many available books; with time I began to understand that I needed one completely to myself. To keep. There was no bookstore in Lethbridge then, but Southern Stationers offered a short shelf of The Modern Library, and on December 1, 1951 (name and date recorded inside the front cover), I bought W. Somerset Maugham's 1915 novel *Of Human Bondage*. What a title for me, and how utterly typical a novel to find in Canada then: Philip Carey with his club foot and servants and a living of 500 pounds a year and having tea in an absolutely nineteenth-century English world, and his o-so-sensitive and endless search for himself; his *self!* A character I eventually found so effete the sheerest drift of wind off the Oldman River would surely have disappeared him like dust. As he jolly well deserved.

But there was the rug; that remained, an existential burr hooked in my memory. Chapter 106, page 654. Philip suddenly understands what his friend Cronshaw meant when he gave him a

Persian rug which, he told Philip, would offer an answer to his question about the meaning of life: "The answer was obvious. Life has no meaning."

To look to a rug for the meaning of your life? Meaning came through books. No, my mother said, from only one book, the Great Book called the Bible. And when sometimes I could not completely believe her then, I nevertheless wanted to all the more.

There is another other memorable line, on the final page of the novel. Philip asks Sally to marry him, and Sally, that perfect blonde embodiment of calm English beauty, answers without flicker of emotion, "If you like. Oh, of course, I'd like to have a house of my own."

The ultimate desire: a house. At barely sixteen I considered this conclusion less than ludicrous; now I cannot be so sure. The desire for house: it is perhaps too easy for those who have never truly experienced either poverty or depression (both worldwide and/or personal), or deprivation or violence or war, to belittle the idea of suburb, which began in Levittown, New York, for veterans of World War II, and whose Cape Cod and ranch bungalows with their L-shaped living room–dining

room fenced onto cul-de-sac streets mushroomed all over North America. For centuries my forebears had lived in rather similar clusters of homes all around the walled city of Danzig or in the farm villages on the Vistula delta of Poland and later on the steppes of Ukraine and Russia; only the cruelty of Canada's Homestead Act forced them here on the western prairie into the sometimes devastating isolation of single farmsteads. I worked myself through university building suburb houses, beginning with Art Batty Construction in the Lethbridge district of Glendale east of Mayor Magrath Drive in 1953. At eighteen I could walk the top plate of a 2×4 wall as easily as stroll down a sidewalk; when the milk wagon trotted by, we construction grunts bought chocolate milk and strawberry ice cream, sawed the cold bricks in half and ate them with woodchip spoons. Glendale, and over the years all the Lakeviews, Tudors and so on, then the University Wests to Varsity Heights and Indian Battle Heights—until in 1999 the people who wanted houses discovered, again at long last, the beauty of the deep river valley, its marvellous shelter from the wind, and now you can follow the bent pavement south, down into the ultimate Lethbridge

double-garage-facing-the-street-with-golf-course suburb of Paradise Canyon.

Paradise. Canyon. Somehow contradictory words I would not immediately associate with real estate development. To be downright bookish about it, for Dante in *The Divine Comedy,* Hell is a canyon, one of increasing horrors as it circles down into the frozen centre of the earth; his Purgatory is a dazzling mountain, but Paradise culminates in the vast white blossom of a rose on whose petals are seated the spirits of the Forever Blessed. Ultimate paradise is flower and sky.

Well, paradise. The Segregated Area has been gone for over half a century; only one or two vivid, austere brick buildings, a single wooden cottage overgrown and moldering on an alley, remain; paradise on earth may well be for each of us wherever we can imagine we find it; it may very well be in an unforgettable river valley. In the golden evening light of Paradise Canyon, the Canada geese that raise their long necks from the golf greens to watch me walking, the motionless scatter of deer resting on the hillside above the brick and stucco houses as I drive by, seem to me to be the perfect fauna reflections of the incorruptible river that continues to slip between rounded stones and past tall, eroded clay cliffs on its unending and circular journey from the mountains to the ocean to the blue and cloud-blossoming sky.

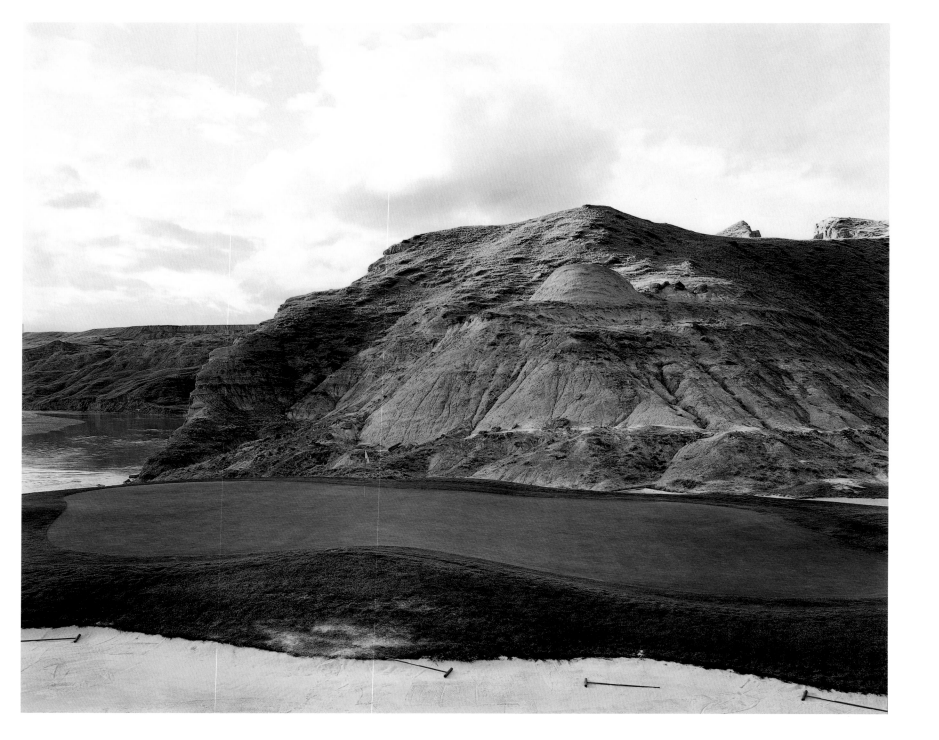

When April snow suddenly

sweeps east from the mountains, people in southern Alberta are invariably confused. This is spring? For weeks we've had temperatures of fifteen, sometimes twenty above, T-shirts and shorts have appeared on sidewalks, crocuses and small cactus on the coulee hills are budding, most of the winter sand has been vacuumed off the streets, and now this? Again? Ten below and more snow than we've seen all winter, thick heavy flakes as if we had been exiled east to the St. Lawrence Valley in February.

The meteorologists are, of course, superbly helpful after the fact. They will tell us exactly why this happened—though they themselves did not anticipate it—as if knowing the scientific reasons will make us all content and happy: "Cold air mov-ing south from Nunavut [it is now an official territory and henceforth can be blamed for most of the worst weather in Canada] has collided with slightly warmer wet Pacific air coming across the northern mountains from B.C." The point is, apparently, that if the Pacific air had come via Vancouver rather than from the north, we'd have had a chinook: that is, warmth and headaches and crazy behaviour and happiness all around, but as it happens, two cold fronts bumping have made a snowstorm.

Weather in southern Alberta is forever the result of something happening far away, something moving in on us.

And meteorologists are wrigglers who thrive in lakes of statistics. Eleven centimetres of snow have

already fallen on April 15, 2000, with perhaps another four or five to come, and then, before they can be stopped they tell us what we try not to think about every spring: that April snow actually happens quite regularly. On April 13, 1996, 4.5 centimetres of snow fell; on April 5, 1993, 19.4 centimetres; and in April 1990, May 1998 and also May 1884—if you listen, they'll happily bury you in a hundred and twenty years of irrefutable snow.

On the vast sloping steppes of southern Alberta, weather is whatever it is—unavoidably weather. And if you were once young in Lethbridge, it is inevitable that you will return again and again. All your life, for parents, for sisters and brothers and cousins and nieces and nephews, for reunions, weddings and, increasingly, as you age, for funerals. Number Two Highway carries you south on cruise control from clear sunlit Edmonton to lowering Calgary and on south, parallel to the long sky of shining mountains.

But today the foothills and the front wall of the Rockies slowly sift away in low grey light; around the homes of Nanton the bushes are clumped with snow, by Claresholm the evergreens and the crotches of green maples are as romantically draped as Christmas cards. Beyond the white ditches, cattle bend into their sprawls of hay, occasional horses stand hip-shot in the snowy stubble, and soon you find yourself driving in a layer of moving mist, as if spirits were breathing hot and low around the wheels of your car, leading you away on an endless stream like thinning memory. Vehicles approach, they float past, silent and drifting as transparent ghosts. When you ease aside at the Oldman River Crossing, down among the layered and bent cottonwoods near Fort Macleod, you see your wheel-wells are hung tight with thick icicles, your entire car has become an antediluvian animal scaled over by the flow of grey frozen slush. In this perfect world of exquisite rime, you have crawled out of the warm belly of a prehistoric beast armoured in steel ice.

And from inside it, on CBC Radio Two, a mellifluous black voice is singing. So tenderly in the sharp and delicate spring air,

I've heard of a city called Heaven,
 And I know I will soon be there.

ACKNOWLEDGEMENTS

Joan Stebbins, formerly director of, and now curator at, the Southern Alberta Art Gallery, has shepherded this project from the start with grace and good cheer. I am indebted to her and to Luke Stebbins, whose knowledge of the prairie is huge. Scott McIntyre is the only Canadian publisher I know who actually cares about the visual arts and who does something about it. Two remarkable people, Phyllis Lambert and Ydessa Hendeles, made personal contributions to the printing, and for this I am deeply thankful. I am grateful to the Southern Alberta Art Gallery for its commitment to the project from start to finish. Finally, without the support of the Canada Council for the Arts, this book would not have taken its present form.

GEOFFREY JAMES

Without Joan Stebbins's steadfast dedication, this book would not exist. I thank her for convincing me to be the textual half of the "double vision" which Geoffrey James's superb photographic narrative of Lethbridge reveals. And also, loving thanks to my sister Elizabeth, who over decades has always made me welcome in Lethbridge, and who allowed me to quote from her teen diary filled with exact dates and tiny, indelible facts memory alone could not have recovered.

RUDY WIEBE